P9-CAN-533

Secrets of the Face

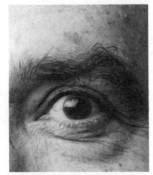

Secrets of the Face

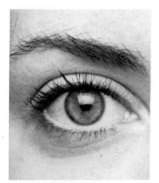

Lailan Young

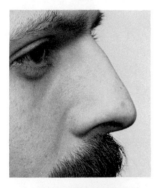

Illustrated by David Arky

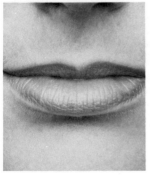

Little, Brown and Company Boston — Toronto

COPYRIGHT © 1984 BY LAILAN YOUNG

ALL RIGHTS RESERVED. NO PART OF THIS BOOK MAY BE REPRODUCED
IN ANY FORM OR BY ANY ELECTRONIC OR MECHANICAL MEANS
INCLUDING INFORMATION STORAGE AND RETRIEVAL SYSTEMS WITHOUT
PERMISSION IN WRITING FROM THE PUBLISHER, EXCEPT BY A REVIEWER
WHO MAY QUOTE BRIEF PASSAGES IN A REVIEW.

FIRST AMERICAN EDITION

Library of Congress Cataloging in Publication Data

Young, Lailan.
 Secrets of the face.

 1. Physiognomy. I. Title.
BF851.Y68 1983 138 83-17524
ISBN 0-316-97710-1

MV

Book designed by Patricia Girvin Dunbar

Published simultaneously in Canada
by Little, Brown & Company (Canada) Limited

PRINTED IN THE UNITED STATES OF AMERICA

Cheltenham Township Libraries 108795
Glenside Free Library

To my
mother and father,
who gave me my Chinese face,
and to

Robin,
who says he loves it

Contents

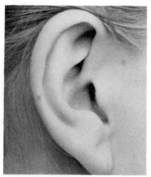

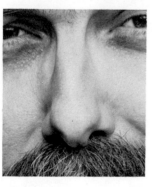

Secrets of the Face

1

What Is Siang Mien?

Faces tell all.

Everyone talks about people as having an "open, honest face," a "careworn expression," or a "cheerful countenance." We talk about kind and evil faces, weak chins, generous lips, mean mouths, intelligent foreheads, and eyes that are seductive, wayward, or mischievous, without ever stopping to think how we would define the appearance that gives them a particular characteristic.

You can probably tell if those you know well are angry, happy, sad, hurt, or tired by looking at their faces. But most people's knowledge of faces ends there.

Only the Chinese have made a thorough study of the art of face reading. They call it Siang Mien (which is pronounced *See-ang Mee-en*). Dictionaries define Siang Mien as "reading faces," "physiognomy," and "telling destiny by inspecting the countenance." The truth is that through Siang Mien you can read the character of anyone you meet, and tell whether his fortune will be good or bad.

A number of eminent scholars have written about Siang Mien, including Professor Joseph Needham of Cambridge University, who, in his encyclopedia *Science and Civilisation in China*, refers to its antiquity. He observes that "one very interesting outcome of physiognomy and its offshoot, cheiromancy (palmistry), was the early discovery by the Chinese of the practicability of identification by fingerprinting."

The Chinese have practiced many forms of divination for more than seven thousand years. Emperors and government officials called on experts to advise them about journeys and military expeditions, marriages, affairs of state, and anything that might affect Man and Nature, Heaven and Earth.

Siang Mien has been important in China for more than two thousand years. It has always been a secret, taught by masters to a few disciples. Books were written about it, and most were stored in palace libraries for use by the emperors. But, throughout China's turbulent history of wars and rebellions, palaces were looted and books burned.

Most of what is known of Siang Mien today has been passed down through the ages by word of mouth. This knowledge has been added to by scholars and students of Siang Mien who have traveled the world to observe the faces of people in many lands.

Other forms of divination in China have faded in importance or become mere parlor games. Siang Mien has survived because, as the mirror of the soul, the face really does reveal a person's inner thoughts, intentions, and feelings better than anything else.

Chinese families in many countries practice Siang Mien without ever calling it by its name. My own parents warned against marrying anyone with small earlobes or a flat nose.

Anyone who has been among the Chinese will have noticed the Chinese habit of staring. When the Chinese stare, it is your character that is being assessed.

The close relationship they see between your char-

acter and your face is expressed in their ancient saying:

> You may strike a man's head, but never
> strike him in the face;
> Even if you revile him, do not attack his
> character.

"Good" faces are not necessarily those you might consider beautiful or handsome. Someone may be ugly as sin, yet have a face blessed with good fortune. High foreheads, straight noses with plump tips, thick ears with big lobes, rounded chins, and a mole near the top of the ear are some of the luckiest and most desirable features.

Siang Mien begins by identifying the shape of the face. From that, the broad elements of character can already be discerned. Next, the face is examined section by section — forehead, eyebrows, eyes, nose, mouth and teeth, ears, cheeks, and chins.

The Chinese art of face reading is based upon detailed analysis of the structure and permanent features of the face, so it can best be applied to those whose facial features are fully formed. That usually means those who have passed the age of fifteen. Wrinkles that come with age are not important, but creases, indentations, and lines that do have significance when they occur in strategic areas of the face are included and interpreted in this book.

Siang Mien also studies important moles and their meaning, as well as special areas of the face that tell about health, wealth, careers, friendships, family relationships, and love.

As always in life, faces contain contradictions. Contradiction is an essential element of the human personality. Siang Mien shows where the internal contradictions lie, and tests the strength of the features to determine which feature is likely to predominate in any given circumstances.

And so, to get the most from Siang Mien, you should consider the entire face of the person you are examining, and then — like a caricaturist — you can single out a predominant facial feature that interests you, and read about its significance in this book.

Some features of the face are likely to change with age. Siang Mien naturally reflects aging and the way in which personality and character develop and change with the passing years. Any Siang Mien reading is true at the time it is made. You can see how life is treating you by comparing your present face with its appearance in your old photographs.

No artificial or accidental changes can affect or alter the truth in your natural face. Plastic surgery — like the effects of an accident or illness — makes no difference to your character. You are not a better person because you have had a face-lift.

What you learn about your personality from the study of your face with the aid of Siang Mien can always guide your future conduct, benefit your career, and improve your relationships with others. By studying their faces you will understand them better, too.

In fact, getting to know people without even speaking to them can be done anytime, anywhere, by practicing Siang Mien.

At-a-Glance Guide
to Facial Features

This At-a-Glance Guide will help you speedily read character and personality in the human face.

Use this quick guide to identify the shape of face or type of feature that you are interested in. Then you can quickly turn to the pages that will tell you what it reveals about your subject's personality and destiny.

Face Shapes

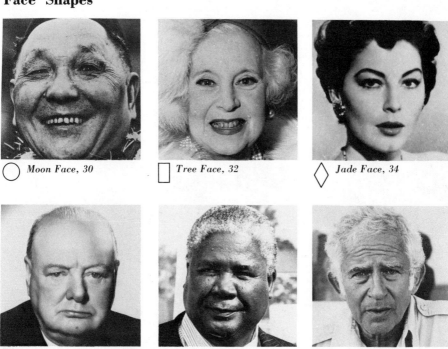

Moon Face, 30 Tree Face, 32 Jade Face, 34

Iron Face, 36 Earth Face, 38 Fire Face, 40

Face Shapes (*continued*)

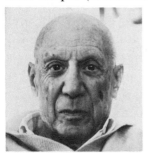

▽ *Bucket Face, 42*

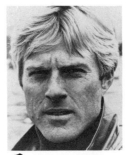

王 *King Face, 44*

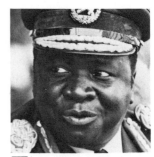

☐ *Wall Face, 46*

Forehead

The best forehead, 52, 64

Pointed, 52, 53

Narrow and shallow, 52

Narrow or flat or bumpy, 52

Narrow forehead, hairline starts well back, 54

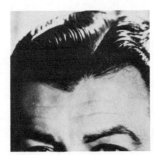

V hairline, 212

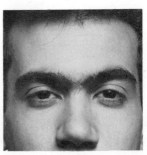

Low hairline, 54

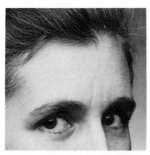

Narrow, shallow forehead, hairy corners, 55

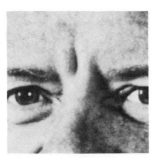

Worry crease, 204

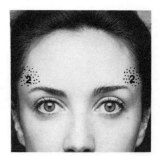

Pulse Points, 204–205

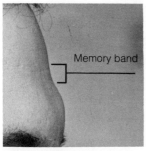

Memory band

Memory band indented, 56

Memory band nicely curved and rounded, 55

Memory band protrudes, 55

Memory band flat, 56

Baldness, 56–57

White hair, 56

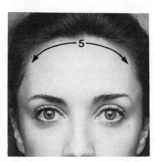

Friendship Region, 210–213

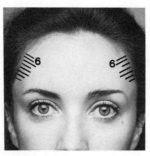

Parental Region, 213–215

Career Region, 206–208

Eyebrows

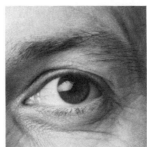

The best eyebrows, 62–64

Brooms up, 65–66

Brooms down, 65–66

Hero's, 67–68

Chaotic, 68

Triangle, 69

Knife, 70

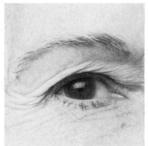

New Moon, 71

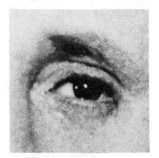

Character 8, 72–73

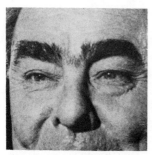

Eyebrows pressing on eyes, 74

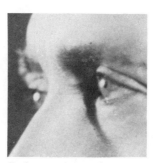

Eyebrows pressing on eyes, prominent bone above eyebrows, 74–75

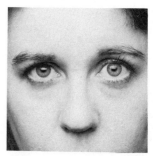

One eyebrow higher than the other, 76

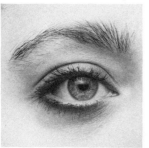

Hairs growing vertically at beginning of eyebrow, 76–77

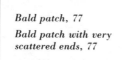

Bald patch, 77
Bald patch with very scattered ends, 77

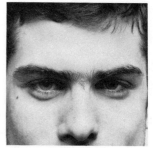

Joined, 77–78

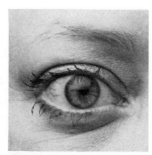

Joined, very thick, 80

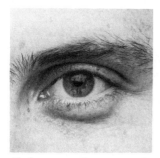

Very short, 79

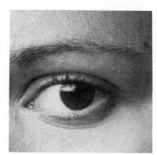

Thin, 81

Eyebrows (*continued*)

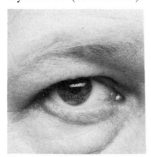

Very pale, 81–82

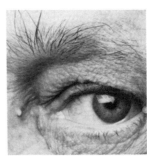

Meager, 82–83

Curly, 83

Curly with prominent bone structure situated just above brow, 83

Eyebrow hairs growing down, 84–85

Eyebrow hairs growing down, dark and thick, 84–85

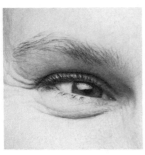

Visible roots, 63, 85–86

Life Region, 202–203

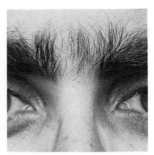

Hair growing between eyebrows, 203

Eyes

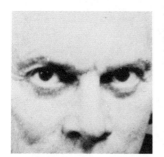

Powerful Gaze, 88–89

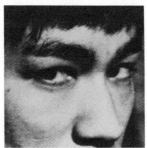

Shifty Gaze, 90–91

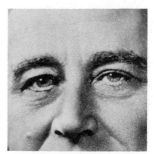

Open Gaze, 92

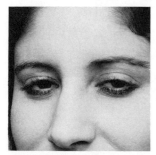

Sleepy Gaze, 94

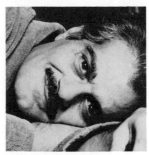

Sensuous Gaze, 96–97

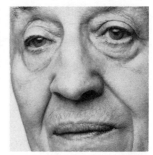

Vacant Gaze, 95

Angry or Mad Gaze, 98–99

Drunken Gaze, 94
Near- or Farsightedness, 93
Blinking, 91

Eyes of different sizes, 107, 108

Eyes (*continued*)

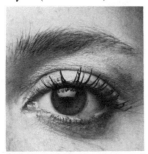

Dragon, 99–100

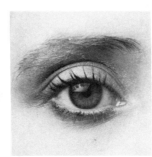

Cow, 100

Peacock A, 100–101

Peacock B, 100–101

Tiger, 101–102

Fox, 101–102

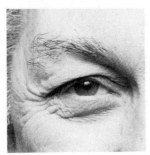

Pure Triangle, 103

Chicken, 104

New Moon, 105

Eyes (*continued*)

Large, 106

Small, 106–107

*One eye higher than the other,
107, 109*

Eyes wide apart, 110–111

Eyes close together, 110, 111

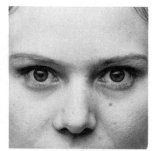

Eyes slant up, 112

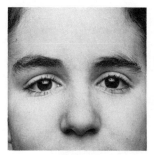

Eyes slant down, 112

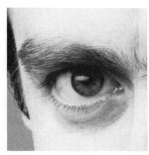

Deep-set, 113

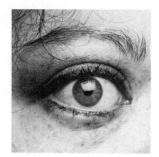

Protruding, 114

Eyes (*continued*)

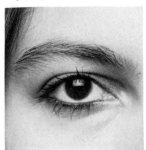

Pointed inner tips, 115

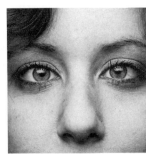

Cross-eyed, 116

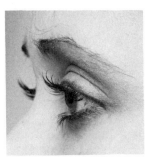

Long eyelashes, 117

*Eyelashes that curl or
turn up, 117*

*Very thick eyelash
hairs, 117*

*Very fine eyelash hairs,
117*

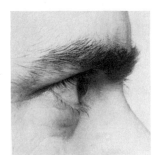

Single eyelids, 118

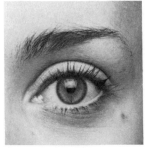

Double eyelids, 119

Eye color, 119–120

Bluish whites, 123

*Foggy or yellowish
whites, 123*

Gray clouds, 120

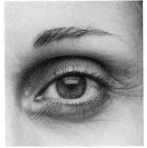

Two whites, 120–121

Eyes (*continued*)

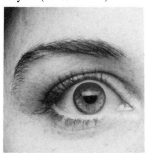

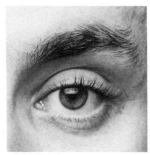

<table>
</table>

Four areas of white
showing, 122

Red eyes, 123

Red dots clustered in
whites, 123

Red lines across iris,
123

*Three whites — one above
iris, 121*

*Three whites — one below
iris, 122*

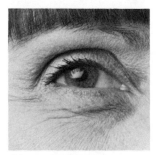

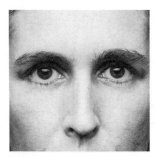

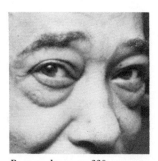

Lines under eyes, 219

*Indentations at corners of
eyes, 219*

Bags under eyes, 220

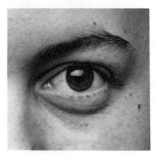

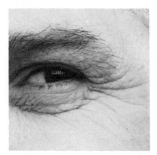

*Sunken or bluish area under
the eyes, 221*

Crow's feet, 221

Love Region, 218–221

Nose

The best nose, 125–127

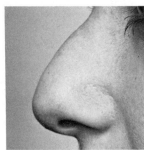

Arched, 127

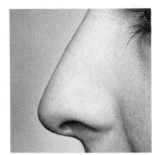

Straight, 127, 128

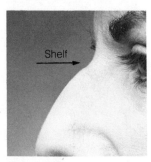

Shelf →

Roman, 129

One or more bumps, 129

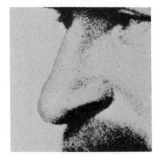

Downward-pointing, 130

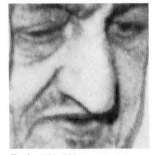

Eagle, 131–132

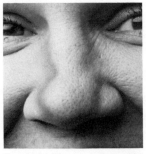

Crooked with a round tip, 132

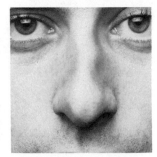

Crooked with a pointed tip, 132

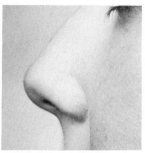

Short, 133

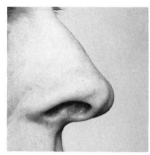

Long nose and large nostrils,
133

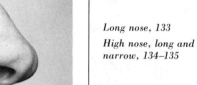

Long nose, 133
High nose, long and
narrow, 134–135

High, 134

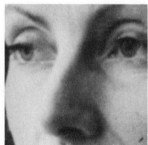

High with narrow, prominent
bone, 135

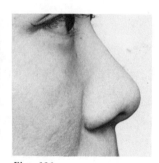

Flat, 136

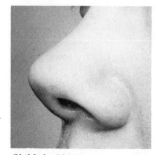

Childish, 136

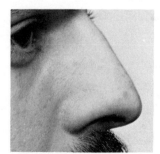

Thin nostrils, 137

Thin nostrils that show
when viewed full face,
137

Nose (*continued*)

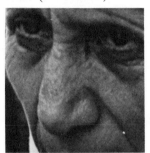

Plump, 138, 139

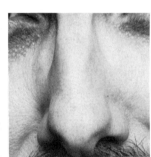

Thin with sunken sides, 139

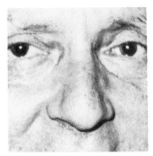

A good nose for making money, 209

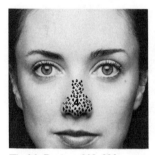

Wealth Region, 208–210

Health and Energy Region, 215–217

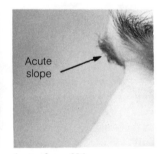

Acute slope

Acute slope, 216

Mouth

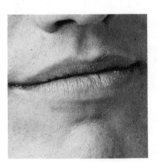

The best mouth, 142–144

Thicker upper lip, 144

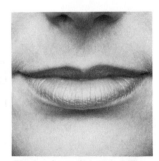

Thicker lower lip, 144, 145

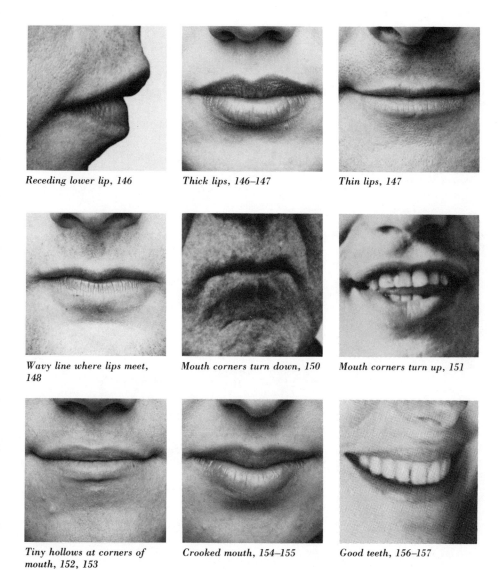

Receding lower lip, 146

Thick lips, 146–147

Thin lips, 147

Wavy line where lips meet, 148

Mouth corners turn down, 150

Mouth corners turn up, 151

Tiny hollows at corners of mouth, 152, 153

Crooked mouth, 154–155

Good teeth, 156–157

Mouth (*continued*)

Small teeth, 157

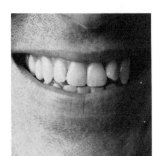

Long teeth, 157

Gaps between teeth, 158

Teeth varied in size, 159

Visible gums when a person smiles, 149

Jen-chung wider at bottom, 160–161

Parallel Jen-chung, 160–161

Jen-chung wider at top, 161

Large teeth, 157
Teeth slope inward, 159
Teeth protrude, 148
Thick, ivory-colored teeth, 159
Thin teeth, 159
Very white teeth, 159

Ear

*Well-proportioned and large,
165*

Small, 164–165

Large, 164

*Ears should be between the
two lines, 166*

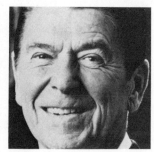

Low-placed ears, 23

Flat, 168

Protruding, 168, 169

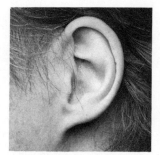

Round, 170

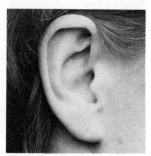

Squarish, 170

Ears (*continued*)

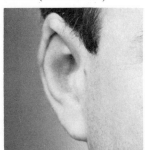

Pointed tips (upper or lower), 170

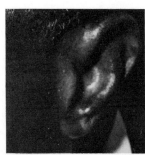

Thick, 171

Thin, 171
Long, 170

Ear markedly wider at top, 172

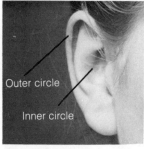

Outer circle

Inner circle

Outer and inner circles, 173

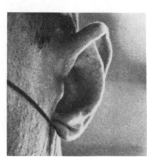

Ear with prominent inner circle, 173

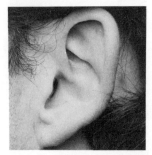

A bend on the outer circle, 174

Small lobes, 174–175

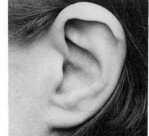

Small lobe with a round, wide inner circle, 174

Ears (*continued*)

The best lobe, 175

Protruding lobes that slant toward the mouth, 176

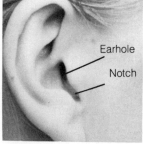

Earhole

Notch

Notch and earhole, 176

Earhole tucked away deeply, 176

Small, shallow earhole, 176

Wide earhole, 176

Hairy ear, 177

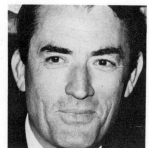

Ears of different sizes, 49

Cheeks

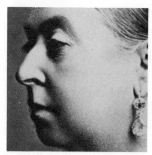

Rounded cheeks, 179–181

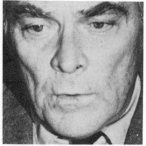

Prominent cheekbones, sunken cheeks, and strong jaw, 182, 183

High cheekbones, 182

High cheekbones and severely sunken cheeks, 182–183

Cheeks (*continued*)

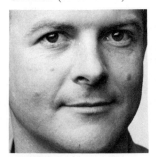

Low, flat cheekbones, 184

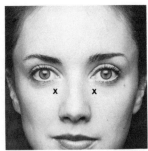

Sunken areas of cheek below inner corners of the eyes, 185

Line across cheekbone, 185

Chin

Protruding, 188

Square, 189, 190, 208

Round, 189, 190, 208

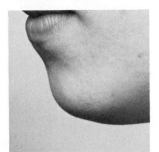

Receding, 190

Full, rounded chin, smooth and free from bumps, 189, 190

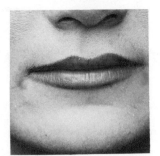

Small indents below corners of mouth, 190, 191

Fleshy, circular area in
center of chin, 191

Cleft or indentation,
192

Cleft with dimple, 192

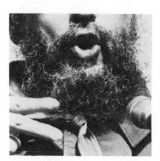

Thick beard, 194

Sparse beard with bald
patches, 195

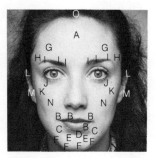

Moles, 198

3

The Face Shapes

Most faces recognizably fit one of the ten shapes described in this chapter. Some people, though, have faces that are one shape in the upper half, another in the lower. They will take characteristics from both basic shapes.

The shape of the face reveals the broad elements and general tendencies of character, which are added to and modified by the more specific characteristics revealed by the further study of individual features. Therefore, let's start with the face shapes and then go on in the ensuing chapters to examine what Siang Mien tells about areas of the face, and individual features and their significance.

Moon Face

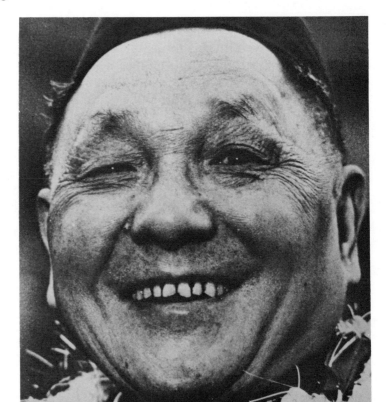

Deng Xiao-ping — Moon Face

The Moon face lacks a prominent bone structure, its roundness and curves being the result of soft flesh.

Siang Mien sometimes compares the Moon face to water, for as water can change course and fit into any

shape, so, too, can those with Moon faces adapt to situations and conditions.

Because of a tendency to be overweight, Moon-faced people prefer mental to physical activities, and many are lazy. Some are greedy, too, and there is a famous Chinese story originating in the Ming dynasty, which can appropriately be told to any greedy Moon-faced person with a sense of humor.

The story tells of a poor man who met an old friend who had become an immortal. After hearing his friend complain about his poverty, the immortal pointed his finger at a brick, which turned instantly into gold. He gave it to his poor friend.

When the poor man said he needed more, the immortal gave him a big gold stone, but still the man was not satisfied.

"What more do you want?" asked the immortal friend.

"Your finger," was the reply.

Siang Mien character reading suggests that the importunate pauper was a Moon-faced person.

Siang Mien shows that a sales career suits many with Moon faces. Those who have a full Moon face find marriage a nuisance, even a bore at times, and also have doubts about whether it is a good idea to have children.

Large or round eyes are an insurance against serious financial problems for those with Moon faces. If the eyes are small and age lines appear beneath them before age thirty, the period from ages thirty to thirty-five is important, and care should be taken of health, especially diet and sleep.

Tree Face

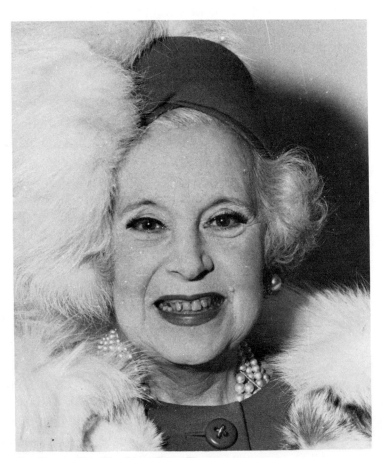

Barbara Cartland — Tree Face

There are more Tree faces than any other face shape.

The Tree face gives an impression of length, rather than width. It is about the same width across the forehead, cheekbones, and jaw; the general outline is oblong.

Siang Mien shows that, like trees, those with Tree

faces are able to weather storms, spreading their branches to protect their dependents and territories.

Those with Tree faces are naturally inclined to be assertive, even belligerent. According to Siang Mien, those tendencies are sometimes repressed, but if they are released, Tree people discover in themselves an inventiveness and a resourcefulness that few would suspect. This discovery is like a tree breaking into blossom.

But, one should not expect anyone with a Tree face to acknowledge — or repay — favors. Trees develop slowly but steadily, in their own good time.

Relationships with the family can be marred by petty aggravations, especially if the Tree-faced person feels cornered in a boring or unrewarding job. For them, it is like being trapped in a dark and over-crowded part of a forest.

Tree-faced men and women derive more satisfaction if they are able to lead, rather than be led. The tree that is pruned and trained is less complete than one that grows naturally.

If the forehead is good (round, wide, deep, and smooth) but the chin is poor (very pointed, narrow, or receding), then the period up to age thirty is sounder than life after fifty. A smoothly rounded or square chin indicates that the period from fifty until the angels sing has its rewards. One's luck is enhanced if the eyebrows are good (long, evenly arranged, arched in a gentle curve, and tapering to a point), or if the eyes are clear, strong, and rather large.

Siang Mien has special advice for balding Tree-faced men: it is essential to keep remaining hair healthy by careful cleaning and grooming to prevent a decline in health and fortune.

Jade Face

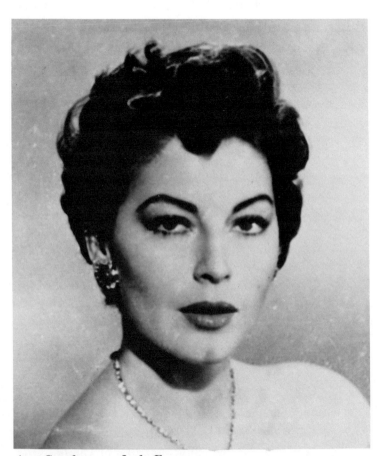

Ava Gardner — Jade Face

The Jade face is recognizable by its narrowness at top and bottom and its wide middle with prominent cheekbones. Indeed, it is the cheekbone that distin-

guishes the Jade face from the Tree face. Both give an impression of length, rather than width; but the cheekbones are more noticeable in the Jade face, while the sides of the Tree face are straighter.

Jade is valued by the Chinese for its beauty and mystical qualities and is seen as a symbol of good luck. Likewise, possessors of a Jade face are likely to have fortune through their lives.

Jade is also very hard, and the masters of Siang Mien believe that possessors of a Jade face are tough and have a will to survive.

For many with Jade faces, early life is marred by being misunderstood or undervalued by others. Some are born poor, but memories of unhappy or difficult times act as a spur to make the most of every opportunity. Siang Mien identifies these people as self-made, and able to overcome setbacks.

During the Ch'ing dynasty General Tsang Kuo-feng, himself noted for toughness toward friend and foe alike, chose for his front-line troops those with Jade faces. As one who practiced Siang Mien, he knew the strength and fighting qualities of Jade men.

Yet, despite their vigor, Jade people are sometimes very unpopular; many harbor grudges and make sure that, sooner or later, the culprit who upsets them pays for it. Siang Mien says that Jade people who think they are doing their duty thoroughly are sometimes regarded as egotists, or as being unable to delegate responsibility.

The most successful Jade faces are straight. This is not the same as "keeping a straight face," but means a face that, when viewed in profile, is even and regular and free from bumps.

Iron Face

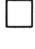

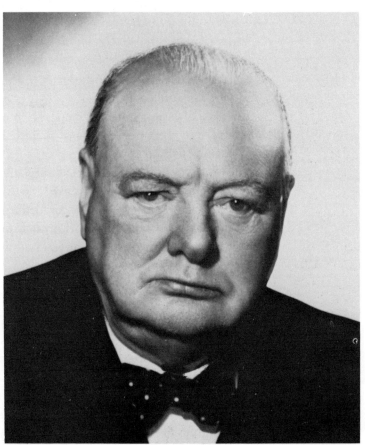

Sir Winston Churchill — Iron Face

Iron faces are square. The forehead and jaw are wide, but the face is shorter than the Tree face and has a stronger bone structure than the Moon face.

Siang Mien considers the square a symbol of stability and incorruptibility, and in the time of the Sung dynasty, the name of "Man with the Iron Face" was given to a statesman called Pao Cheng. He was honest, selfless, and dedicated to what he thought was right, but so immobile of countenance that he never smiled in his life.

Fortunately, those with Iron faces smile nowadays. As iron is tough, but softens at high temperatures, so those with Iron faces know when it is time to be pushy and when it is appropriate to hold back. Rather than make a mistake, the Iron man or woman prefers to weigh matters before taking action, but once their minds are made up they do their best to see the project through. Iron-faced men and women hold strong and deep convictions and are apt to be stubborn. Those with Iron faces have many of the qualities of which top politicians and statesmen are made.

Iron-faced people are exceptionally faithful mates if they are fortunate enough to find understanding and appreciative partners. Otherwise they are apt to roam.

Earth Face

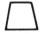

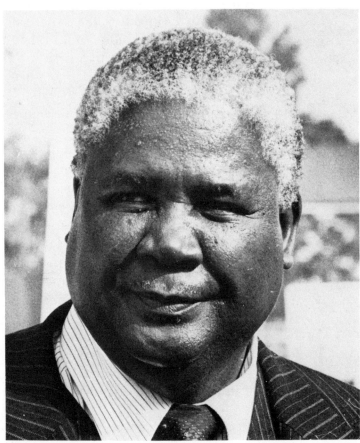

Joshua Nkomo — Earth Face

The Earth face has a moderately wide forehead, wide cheekbones, and a still wider, square jaw.

Chinese legends tell of the chaotic creation of the earth from an egg that separated, its light elements rising to form the sky, and its heavy elements dropping down to make the earth.

Siang Mien links this story of the beginning of the earth with the Earth face. Those with Earth faces are endowed with the heavy elements. They are aggressive, especially if their face muscles are firm. Most are ungrateful and are apt to be spiteful. Quick to take offense themselves, their own down-to-earth manner is equally offensive to others.

This earthy, sometimes antisocial behavior results from a craving for knowledge. They are in a hurry to advance in life. Their resilience is as admirable as their willingness to learn is remarkable.

For thousands of years the Chinese have admired scholars and those who seek knowledge. But the warning given by Confucius against the dangers of incorrectly applying what is learned is just as valid for Earth-faced men and women today:

> He who learns but does not think, is lost.
> He who thinks but does not learn, is in great
> danger.

Relationships with a marriage partner and children are sometimes strained, for the Earth-faced parent can be tough and demanding. Stubbornness, too, is a characteristic of those with this face. But provided they can learn to admit to any serious errors of judgment, they can find that stubbornness is a help, rather than a hindrance, in life.

Fire Face

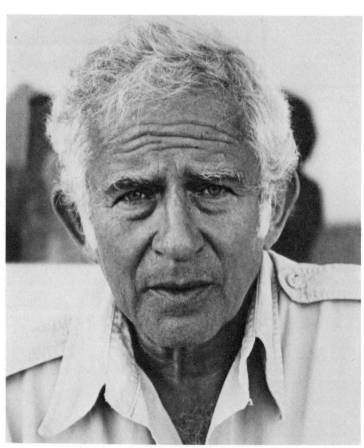

Norman Mailer — Fire Face

The Fire face has a wide forehead and high cheek-bones. It tapers to a narrow jaw and a long chin.

Siang Mien compares this face to a fire, and those with Fire faces are bright, sensitive, and ambitious. When fire takes hold of something it spreads fast; the Fire-faced person is quick to learn, the wide forehead a sign of intelligence.

If the hairline is set well back, this is a further indication of intellect. Americans also recognize this feature, calling someone with a high forehead an "egghead."

Owing to their sensitivity, those with Fire faces are liable to make mistakes in the choice of partners for intimate, long-term relationships. Oversensitive Fire-faced people can meet further problems arising from an innate suspicion of the actions and intentions of others. In short, it is difficult, sometimes impossible, for them to trust other people.

"If what we see before our eyes is doubtful, how can we believe all that is spoken behind our backs?" is a famous Chinese proverb that has particular poignancy for the Fire-faced person.

Bucket Face

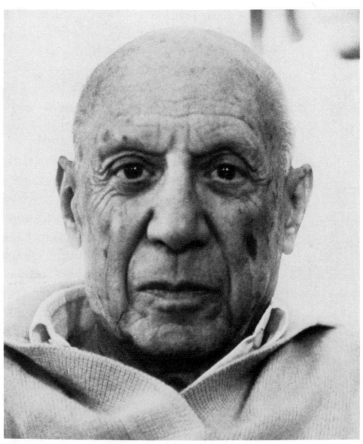

Pablo Picasso — Bucket Face

The Bucket face has a wide forehead and tapers in at the sides. It bears a slight resemblance to the Fire face, but is broader, with a wider chin and jaw.

Though it may be unflattering to discover that one's face is called a Bucket, it is, in many ways, an auspicious face to students of Siang Mien.

Those with Bucket faces appear calm and well-balanced, and are able to maintain this impression even when things are going badly for them. Their air of stability can conceal a great deal of inner uncertainty and turmoil.

If those with Bucket faces are to succeed in life, early on they show evidence of their intelligence and astuteness. Some of their ideas would be brilliant, if given a chance to emerge. But this face also belongs to those who experience periods of gloom and bouts of daydreaming that can cause the quality of their work to deteriorate.

Most Bucket people are kind, though it is difficult to know whether they act from the heart, or only in order to be praised. They are likely to be proud, patriotic, and to have an awareness of their own importance.

Anyone involved in close physical and emotional relationships with them can easily feel rejected, for no one is quite sure what is really going on in their minds.

King Face

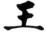

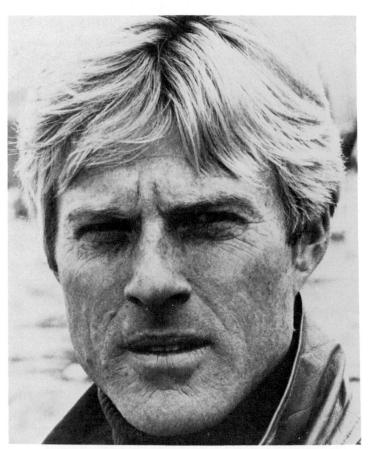

Robert Redford — King Face

Siang Mien chose the symbol above to represent the King face; it is the Chinese written character for "king."

The King face is very bony, and the forehead, cheekbones, and jaw are prominent.

In Imperial China, emperors were honored as king-priests, guided in their actions by Heaven. Evil rulers, it was believed, would fall from grace by the withdrawal of heavenly patronage, as described in a Chinese proverb:

> He who succeeds becomes Emperor,
> He who fails is a bandit.

This is the face of a leader, though many King faces resist — consciously or unknowingly — an inclination to lead, and are themselves led into bad company. Siang Mien warns King-faced people against bad influences such as the underworld of gangsters, informers, and spies. Although King faces are not likely to be led astray by such people nowadays, they should be aware of susceptibility to bad influences.

King-faced men and women who accept the challenge to lead find that their gift is heightened by natural militancy, toughness, and persistence. They do not give up easily, nor do they suffer fools gladly.

Many can turn disaster into success; these are the rich ones, but they are also selfish. Siang Mien notes that even successful Kings are liable to a life of changing fortunes, so overconfidence does not pay.

Siang Mien cautions against spite. When confronted with the failure of a project or anything that is important to them, King faces are tempted to scuttle a relationship or project rather than permit others to benefit or derive pleasure from it. Siang Mien stresses that vengeful acts not only put a King's fortunes at risk, but also increase the probability of sudden, unpleasant repercussions: a sobering thought.

King faces like everyone to agree with them and do not form close relationships easily. Life with a King-faced husband or wife is often turbulent.

Wall Face

Idi Amin — Wall Face

The Wall face is much shorter than any other face, and also wide.

This is the face of a survivor, someone whose sur-

vival record can be compared to the Great Wall of China itself.

More than two thousand years ago, the first Emperor of China ordered a wall to be built to protect his state against raiders from the north. Built 3,750 miles across mountains, without the aid of machinery, it is the only man-made structure the American astronauts could identify from the moon.

Like the Great Wall, those with Wall faces can withstand harassment and attack, and their skillful parrying is victorious in many arguments. They are alert to danger, helped by the notion that "walls have ears" — as often quoted by the masters of Siang Mien as it is outside China.

Those with Wall faces display a quick temper, impulsiveness, and an inability to plan ahead properly that causes many good ideas and projects to crumble. Siang Mien masters have said of those with Wall faces: "Last night they thought over a thousand plans, but this morning they went their old ways."

Given a choice, those with Wall faces much prefer to shrug off problems, and they do not like to think about the future.

As marriage partners, Wall-faced people can annoy and frustrate, causing their loved ones to feel that they are banging their heads against a brick wall. It is difficult, sometimes impossible, for a Wall-faced person to say "I'm sorry."

Women with Wall faces are tempted to wander off in search of adventure and fun with other men if they are not satisfied with their partners, or if they think a newcomer can offer them more.

Irregular Face

 Few people have a face that is totally Irregular, which is fortunate, for this can be a face with few propitious qualities. However, many of us have elements of this shape.

In Siang Mien the symbol selected for the Irregular face is the written Chinese character for "use," chosen not only because it resembles a lopsided face, but also because "use" may suggest the attitude of someone who leans on others, draining them of energy and spirit.

The unevenness of this face can be present in a number of ways: one side can be larger, longer, or wider than the other. The Irregular face can be bumpy, with a crooked nose or the mouth off center. These could be indications of emotional weakness.

Remember, though, that some facial irregularities may result from an accident or illness. These are to be disregarded; Siang Mien does not associate them with character defects.

Those who have studied Siang Mien believe that to tread on the toes of anyone with a severely Irregular face is asking for trouble, for such a person is capable of wreaking awful revenge.

A totally Irregular face is believed to be a sign of mediocrity, and, as mentioned previously, many of us do have traces of this face. Awareness of one's own limitations and problems is the best way of overcoming some of the shortcomings attributable to the Irregular face.

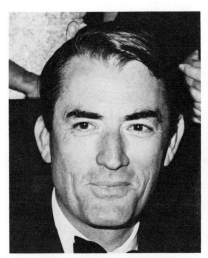

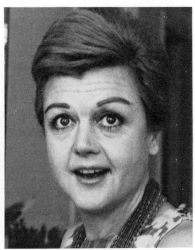

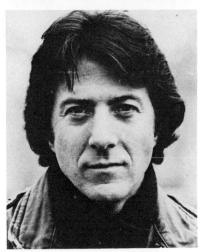

Few people have totally irregular faces, but many have some uneven or irregular features. This does not stand in the way of achievement, as these pictures show.

Gregory Peck has ears of different sizes, and one protrudes more than the other

Angela Lansbury has one eye slightly higher than the other

Dustin Hoffman's mouth is off center

4

The Three Zones

We have seen that in Siang Mien there are ten basic face shapes.

Siang Mien then divides the face into three zones:

1. The forehead, which reveals a person's mental capacity
2. The zone from eyebrow to nose tip, which reveals a person's luck or fortune and ability to overcome obstacles
3. The zone from nose tip to chin, which reveals how well suited a person is for senior citizenship and the enjoyment of old age

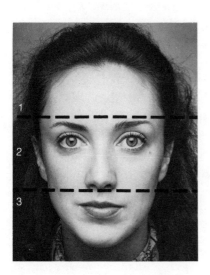

The influence of each zone is strongest at a different point in a person's life: the forehead has its greatest influence during youth and early adulthood, the eyebrow to nose tip zone during the middle years from thirty to fifty, and the nose tip to chin area from fifty through old age.

1. The Forehead

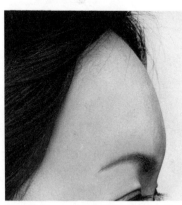

Smooth, rounded forehead

The forehead, according to Siang Mien, determines the extent of a person's intelligence and the ability to learn.

A well-shaped forehead is the sign that a person is well endowed with intelligence. If the eyebrows are also good — defined by Siang Mien as long, even, arched brows that taper to a point — intelligence is further increased. (There is more on eyebrows in Chapter 5.)

The best forehead is *smooth, rounded, and also wide and deep;* that is, wide across the forehead and from the hairline to the eyebrows. Such a forehead is the mark of cleverness, clear thinking, and an ability to act decisively and correctly. However, not even those with the most superbly shaped forehead can make full use of their talents if the top of the head is flat, instead of rounded, or if their eyebrows are badly shaped.

A poorly shaped forehead is one that is *bumpy, flat, very narrow, or pointed.* A forehead that is *narrow and shallow* in depth reveals a disorganized mind and untidy thinking. An *exceptionally narrow and shallow* one betrays passivity; this person dithers.

Declaring that "clear knowledge is superior to profound knowledge," the sages of Siang Mien divided the forehead into three parts, each representing a

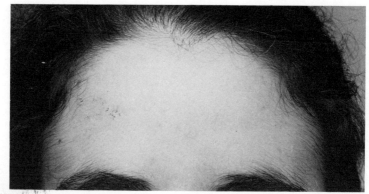

Pointed forehead

different aspect of intelligence, knowledge, and mental skills.

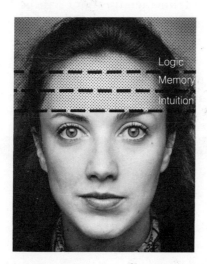

The topmost area defines the faculty for logic and deduction.

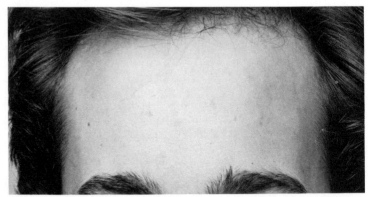

Narrow forehead, hairline starts well back

A *hairline that begins well back* is an additional indicator of intelligence; if the forehead is already broad, the intelligence quotient can be expected to be very high. Even a narrow, pointed, or short forehead contains extra brainpower if the hairline starts well back.

A *very low hairline* that grows well down on the forehead interferes with a person's ability to think

Low hairline

Narrow, shallow forehead, hairy corners

logically when under pressure, and has an adverse effect on the intelligence quotient. It also suggests difficulties with parents or guardians, who, even if they can assist, are not well disposed to give help, morally or financially.

Individuals with *low hairlines, narrow foreheads, and hairy corners* work harder than most, with little of the financial rewards they hope for; this is particularly so before thirty. These features are also warnings that ill health is likely to be a family problem.

The middle area of the forehead represents memory. The founders of Siang Mien observed that those with a *nicely curved and rounded* area here had the greatest powers of recall and the most reliable memories.

The memory area gives clues to other traits as well. Those whose memory area *protrudes* (more easily seen in profile than full face) tend to be quick-tempered, impulsive, and ambitious.

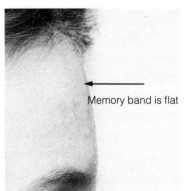 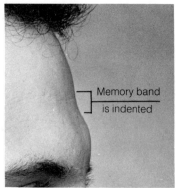

Memory band is flat

Memory band is indented

If a person's memory area is *especially flat or indented*, it is advisable for that person not to have a business or employ others, just as Siang Mien also subscribes to the commonsense Chinese rule: "a person without a smiling face should not open a shop."

The lowest area of the forehead governs "intuition." Siang Mien notes that the most intuitive among us are those whose *eyebrows grow over a protruding bone structure.*

Baldness and White Hair Less important than the three parts of the forehead, but nevertheless fascinating to students of Siang Mien, are baldness and white hair.

There ought to be no shame or embarrassment if a young person's hair turns white. Siang Mien discloses this to be a characteristic of superior mental qualities and — provided the young white-haired man or woman is of good character, as can be told from other features of the face — no harm can come from seeking advice from such a person.

Baldness is another matter, and Siang Mien associates baldness with sensuality.

Among the great bald ones are the three Sages —
Confucius, Lao Tze and Mencius, as well as some of
the Eight Immortals, who gained their immortality
through studying nature's secrets. Both the God of
Longevity and Buddha were practically bald, and
both have enjoyed popularity among the Chinese.

In the time of the Ming dynasty, some Siang Mien
masters added their comments on baldness, recom-
mending that any remaining hair should be kept as
healthy as possible. Dry hair should be treated, they
stressed, or leaner times would occur and might well
prevail.

The forehead is a very important part of the face,
and Siang Mien attaches additional significance to the
Pulse Points and the Career Region, both of which
form part of the forehead. (They are described in
Chapter 13, The Eight Regions.)

2. Eyebrows to Nose Tip

The most important contributory
factors to good fortune and a satis-
factory middle life are a fine pair of
eyes and a good nose. There are
chapters ahead on the eyes and nose
that tell how Siang Mien identifies
and classifies different types of eyes
and noses. Meanwhile, by looking at
the middle section of the face, it is
possible to tell whether or not people
have a good command over money,
and how competent they are in con-
trolling their emotions.

The most successful middle-aged adults are those who possess a good nose and good eyes. Those who have a middle section from eyebrows to nose tip that is *longer* than their forehead are persistent, and capable of overcoming obstacles and adversity. For them there can be no resting on their laurels.

Siang Mien demonstrates that a middle section from eyebrows to nose tip that is *shorter* than the forehead is associated with indecision and, at worst, defeatism.

Experienced students of Siang Mien note that if the middle section of someone's face attracts the attention first because it *protrudes*, this then is a two-faced person: sometimes withdrawn, yet aggressive on other occasions.

3. Nose Tip to Chin

This is the area that reveals to those over age fifty how well suited they are for senior citizenship and the enjoyment of old age.

The earliest masters and disciples of Siang Mien chose fifty as the starting point of old age. To the Chinese, old age is a wonderful time of life, and as they are told from an early age that "a family which has an old person in it possesses a jewel," it is not surprising that most Chinese have no fear of joining the ranks of senior citizens.

There is a Chinese god of longevity, Shou Lao, who is characterized by a large bald head and who carries a peach, itself a symbol of long life. As one of three gods of happiness, it is he who fixes the time of death, inscribing it on the tablet of each person at the moment of birth. To him, fifty is the beginning of a new magical era.

Those with strong *square or firmly rounded jaw-lines and chins* are more likely to adjust successfully to the changed circumstances of later life than those with pointed or receding chins. A further requirement for a fruitful enjoyment of old age is that the lower part of the face from nose tip to chin needs to be as long as, or longer than, the forehead.

Siang Mien also reveals that someone with a *longer forehead than nose tip to chin* measurement is likely to be an introvert, while the person with a *longer lower area* tends to be an extrovert. If the distance between the chin and the top of the neck is very short, this is a feature of a short-tempered person.

5

The Eyebrows

Siang Mien identifies more types of eyebrows than most people would imagine could possibly exist. Many people have two quite different types of eyebrows, in which event they take characteristics from each type. (Some also have two entirely different eyes.)

This not uncommon condition has prompted the Chinese to draw proverbial distinctions between unmatched features that appear on opposite sides of the same face, such as: "The twitching of the left eye and eyebrow denotes wealth; that of the right signifies calamity."

As the eyebrows are more subjected to interference — particularly by women — in the cause of beauty than any other part of the face, it is sometimes tricky to imagine what a person's natural eyebrows were like before they were plucked, or reshaped by penciled lines around, below, or above what should be their natural line.

It is possible, too, that the owners of reshaped eyebrows have forgotten what their brows were like originally. In order to find out about such eyebrows, either you have to see them without their makeup or beautifying aids, or you have to gauge — by carefully observing the eyes and forehead — what the natural line of growth is most likely to be.

According to Siang Mien, eyebrows reveal how well people can organize their thoughts and whether their health is generally good.

It is true that more can be told about someone's health by looking at the Health and Energy Region of

the face (described in Chapter 13, The Eight Regions) than from the eyebrows, but thick eyebrows are indicators of good health, while thin ones accompany a more delicate metabolism. Chinese herbalists believe, as do practitioners of Siang Mien, that the thicker the eyebrow is, the better the state of the kidneys.

The *best eyebrows*, reveals Siang Mien, are shiny,

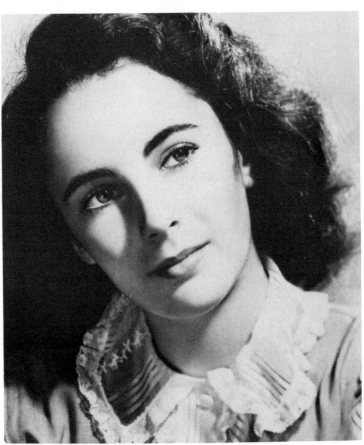

Elizabeth Taylor — The best eyebrows

rather thick, and slightly lighter in color than the hair on top of the head. The exception is for the Iron face (described in Chapter 3, The Face Shapes), where it is advantageous to have eyebrows that are darker than the hair.

The *ideal length* is for the eyebrow to be slightly longer at both ends than the eye; the *ideal width* is half an index finger wide at the widest part (the finger laid flat); and the *ideal shape* is one that is slightly rounded at the beginning, rising into a gentle curve, and tapering to a point at the end.

There is *one further ideal:* the distance between the topmost fold of the eye and the center of the eyebrow should be the width of an index finger laid flat. A narrower measurement than this has an adverse effect on a person's career, while a wider one can show a certain lack of coordination in thought and action.

The most systematic thinkers are those who have eyebrows that have all, or most, of these basic good qualities, and that are also *evenly arranged* and have *visible roots*. But the eyebrows cannot be taken in isolation, for, as previously mentioned, another Siang Mien requisite to clear thinking is a well-shaped forehead — smooth, rounded, wide, and deep.

Thus, although a number of eyebrow types are inferior, many of the disadvantages associated with them can be tempered by having a good, or reasonably good, forehead. Conversely, those with superior eyebrows but a weak forehead find that some good points are reduced or canceled out. (There are more details about the forehead in Chapter 4, The Three Zones.)

At the time when the founding fathers of Siang Mien were formulating their theories about eyebrows, they noticed that there were many variations and that it would not have been accurate to categorize them purely by shape. They remarked that other aspects and qualities, such as thickness, length, and position in relation to the eye, were as important to the understanding of a person's character as the various shapes themselves.

The Ideal Eyebrow

As we have seen from the description earlier in this chapter, the best eyebrow has the following qualities:

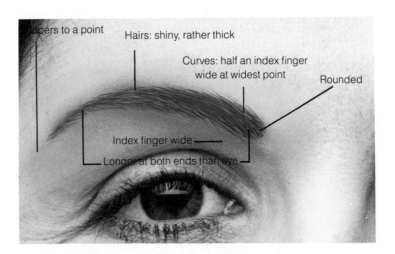

Tapers to a point — Hairs: shiny, rather thick — Curves: half an index finger wide at widest point — Rounded — Index finger wide — Longer at both ends than eye

Provided the forehead is well shaped — that is, smooth, rounded, wide, and deep — and the roots of the eyebrow hairs are visible, the lucky possessor of this eyebrow is logical and more intelligent than most.

Brooms

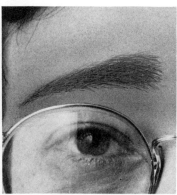

Brooms Up eyebrows *Brooms Down eyebrows*

Siang Mien identifies two types of Brooms: those that are well arranged at the beginning, but scatter at the ends (called Brooms Up) and the reverse: those that are scattered at the beginning, but form a better arrangement at the ends (called Brooms Down).

Both Brooms denote a lack of drive and sufficient ambition to see a project or undertaking through to a rewarding or lasting conclusion. Those with the Brooms Up type of eyebrows give of their best during the first half of a project, while those with the Brooms Down eyebrows show more energy and interest during the second half of a project.

Siang Mien cautions the owners of either type of Broom eyebrow to be alert in their thirties against loss of money or a physical injury. If one's fortune takes a bad turn, little can be done to avoid problems

during this decade, but an awareness of possible difficulties can at least warn against taking unnecessary risks.

The Siang Mien advice to those with Brooms can also be good for everyone: "Don't rely on your present good fortune; prepare for the year it may leave you."

Those whose Broom eyebrows are very dark and thick are likely to be aggressive, even violent, though most are able to exercise enough control to curb any destructive tendencies. The masters of Siang Mien urge these people to remember that "propriety governs the superior person; law, the inferior one."

Provided the rest of the face suggests a strong personality, someone with Brooms Down eyebrows could find success in a political or military career. (See also Eyebrow Hairs Growing Down on page 84.)

Hero's Eyebrows

Hero's eyebrows are very desirable. They have well-defined, rounded beginnings and clear endings.

Those with Hero's eyebrows are energetic, their thoughts are organized, and most are capable of

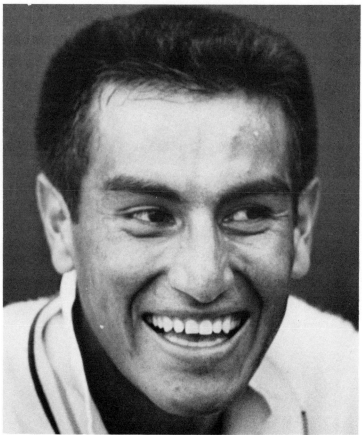

Alex Olmedo — Hero's eyebrows

greater than average foresight. They are ambitious and usually willing to help others. Hero's eyebrows that are especially long and that sweep into an upward slope belong to lucky people who can act with confidence, safe in the knowledge that what they do often turns out to be to their advantage.

Chaotic Eyebrows

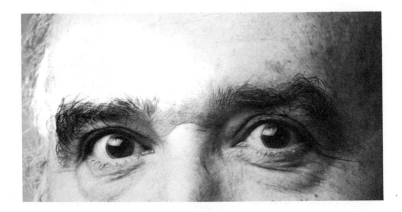

As their name implies, Chaotic eyebrows go in all directions. They are also quite thick, and betray either confused thoughts or difficulties of concentration or, in the worst cases, both. Anyone with Chaotic eyebrows who is also impulsive generally lacks refinement.

Many with these eyebrows have a better physique than most people, but do not know how to use it to advantage.

If the eyebrow endings are badly scattered over a wide area, the years from thirty-one to thirty-four yield a number of unfulfilled hopes and aspirations.

Triangle Eyebrows

Those whose eyebrows form triangles are selfish, but capable of courage when the going is tough.

When they lack ideas of their own, they can usually improve on the ideas of others, thereby benefiting themselves and, if they choose, helping others as well.

Very pointed beginnings and endings of the triangles suggest an acutely decisive nature.

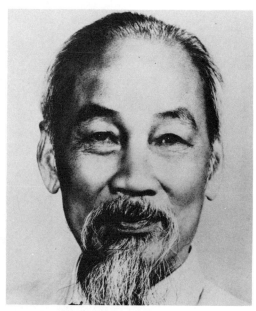

Ho Chi Minh — Triangle eyebrows

Knife Eyebrows

Siang Mien associates these brows with three words: clever, cruel, decisive.

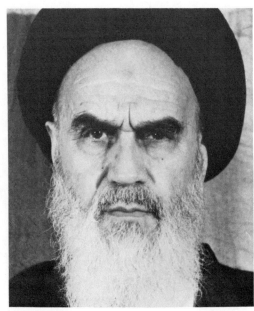

Ayatollah Khomeini — Knife eyebrows

New Moons

Most New Moon eyebrows are thin. Siang Mien reveals that the female owner of *thin* New Moons tends to be emotional and liable to be physically passionate, sometimes losing control of herself. A man with thin New Moons is likely to be exceedingly interested in sex.

Those with *thick* New Moon eyebrows are prone to bouts of hysteria, but strive to control these tendencies through fear of becoming social outcasts.

Character 8

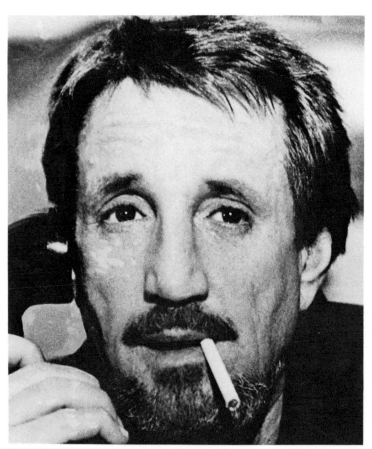

Roy Scheider — Character 8 eyebrows

These eyebrows are so named because they resemble the written Chinese character for "eight."

Early on, the Siang Mien masters declared that such people were "more bright than upright," but later masters, believing that such an aspersion was not fair to all with Character 8 eyebrows, added: "If the eyes do not look sideways, the heart is sure to be upright," by which they meant that, provided they do not squint, people with these eyebrows are of wholesome character.

A further Siang Mien observation of those with Character 8 eyebrows is that they are better suited to be employees than employers, though the masters of Siang Mien discard this reservation if someone has a strong chin or a well-rounded Career Region (the part of the forehead described in Chapter 13, The Eight Regions).

Character 8 eyebrows suggest a difficult period between thirty-one and thirty-four when a career is likely to receive a setback, but if the eyebrow roots are visible there should be fewer problems during these years.

Eyebrows Pressing on the Eyes

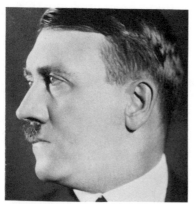

Adolf Hitler — Eyebrows pressing on eyes, prominent bone above eyebrows

As we have seen, the ideal distance between the center of the eyebrow and the topmost fold of the eye should be the width of one's index finger laid flat.

Anything much narrower than this is referred to by the masters of Siang Mien either as "eyebrows very close to the eyes" or "eyebrows pressing on the eyes." Such eyebrows indicate impatience and a tendency to fidget. Thin ones show that a person is likely to be more systematic — though impatient — than a person with thick brows, who is almost certain to be impulsive.

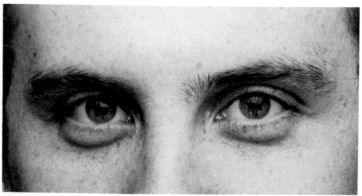

Eyebrows pressing on eyes

Coupled with a prominent bone structure just above the eyebrows, these eyebrows reveal an ambition that exceeds capabilities, which means that those with this combination often set their sights too high and, because of their lack of patience, fall short of their goals.

In the fifteenth century, students of Siang Mien were told the following tale. On the morning of his departure for the capital of China, where he had been appointed to his first important post, a new official was visited by a friend.

"You must always be patient," warned the friend, and the new official promised that he would.

The friend repeated his advice three times, and the official nodded in assent. When the friend repeated his counsel a fourth time, the official lost his temper and said: "Do you take me for a fool? Why do you repeat such a simple thing over and over again?"

His friend sighed. "It is not easy to be patient. I have said it only a few times, and already you are impatient."

One Eyebrow Higher Than the Other

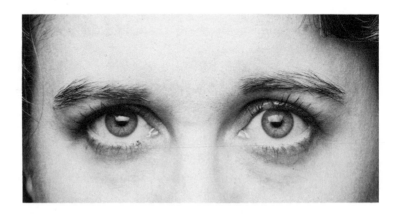

Almost from the moment they are born, the Chinese are encouraged to honor their parents and elders. Siang Mien therefore attaches considerable importance to facial characteristics that give clues about one's parents and filial duties.

Some early Siang Mien observations about family ties are considered obsolete nowadays: one eyebrow higher than the other indicated having a stepfather, or, as was more likely the case in China, a father who had more than one wife.

In a more accurate, refined assessment, which still holds good today, one eyebrow higher than the other means that a person is susceptible to emotional highs and lows. In this instance, Siang Mien does not consider this a significant character blemish in any way.

There are other aspects concerning the eyebrows that are linked by Siang Mien to the family.

If the *hairs grow vertically at the beginning* of the

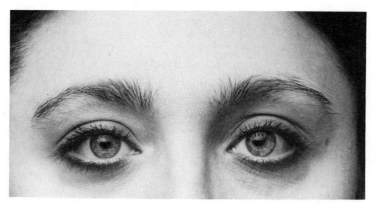

Hairs growing vertically at beginning of eyebrow

eyebrow, this, said the founding fathers of Siang Mien, means that one has brothers or sisters or other relatives of the same generation who are not particularly kind or helpful.

A *bald patch* in the brow used to symbolize a sudden death of a brother or sister or, as interpreted by modern masters of Siang Mien, an emotional break with, or serious disappointment over, a brother or sister or close relative of the same generation.

A *bald patch coupled with very scattered eyebrow ends* warns of the risk of an accident.

Joined Eyebrows

For many centuries the Chinese looked upon scholarship as the epitome of civilization. Some scholars were as famous for their small waists (considered a sign of good breeding), long fingernails (proof that their owners never had to demean themselves by manual labor), or joined eyebrows (brainpower) as

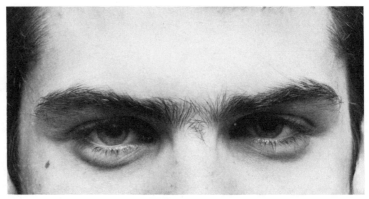

Joined eyebrows

for their literary abilities. Many mandarins — including young and perfectly healthy ones — were supported by attendants when they walked. Perhaps it was the Chinese who first said that there are those who cannot walk and think at the same time.

Such displays of lassitude belong to the past in China, where even joined eyebrows are no longer considered auspicious. In fact, most masters of Siang Mien associate them with people who take offense easily and get depressed too readily, thereby creating mental traps for themselves culminating, at worst, in imaginary illnesses.

These eyebrows often belong to mean and unforgiving people. If success comes their way, it is unlikely before the age of thirty-five.

Very Short Eyebrows

Very short eyebrows can be taken as a general Siang Mien indication that the individual is short-tempered, oversensitive, and impatient. They are probably even more impatient than those with eyebrows very close to the eyes as described on page 74.

Some people with very short eyebrows do not like helping others. Siang Mien advises such people against turning their backs on others.

"The frost only destroys the solitary blades of grass" is a Chinese way of saying that mutual help will avert evil.

Very Thick Eyebrows

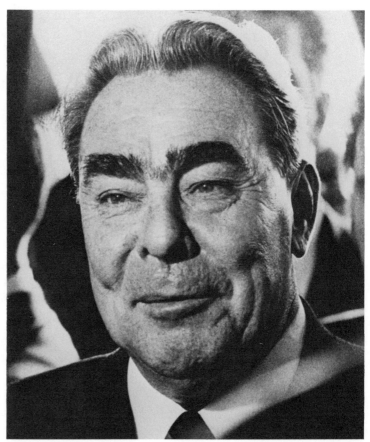

Leonid Brezhnev — Very thick, joined eyebrows

If almost every hair of the eyebrows is very thick and dark, these eyebrows belong to a person with a strong personality, probably an autocrat.

If the eyebrows are also square, this is a proud, tough, and stubborn person, who is likely to be bad-tempered as well.

Thin Eyebrows

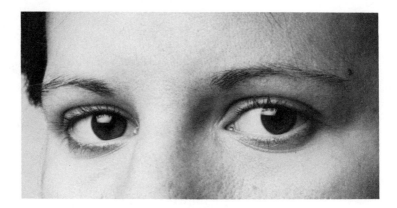

The thinner the eyebrows, the more reserved the person tends to be. Some are also lazy, clumsy, and not at all creative.

Thin eyebrows serve as Siang Mien warnings of health problems, many of them slight but nevertheless bothersome. This should not prevent such people from getting more out of life than those who, though allegedly healthier, engage in sedentary occupations and pastimes.

What appear to be rugged or fierce faces may not be if the eyebrows are thin, for these are the clue to Siang Mien students that such people are not as fierce or tough as they seem.

Very Pale Eyebrows

Those whose eyebrows are *much* paler than their hair are not naturally fast thinkers, say the masters of Siang Mien. Yet, given a goal in life, they can achieve

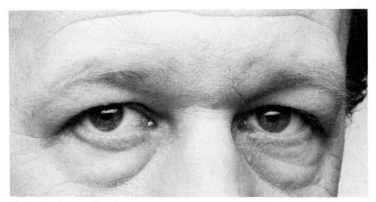

Very pale eyebrows

it on one condition: that they can overcome their in-
herent problems of untidy thinking and lack of fore-
sight. Those who cannot ought to consider working
with their hands in preference to a career that re-
quires clear thinking and decision-making that affects
others.

If the hairs of the eyebrows are not only extremely

Meager eyebrows

pale, but scant and thinly distributed as well, such *meager* eyebrows are a sign that their owners will achieve very little in life.

The early thirties are not especially favorable for most people with light-colored eyebrows, and, as with those who have thin brows, there are health problems, many of them minor but irritating.

However, the masters and students of Siang Mien also subscribe to the old adage that where there is a will there is a way, and many with inferior eyebrows achieve considerable success, at least for certain periods of their lives.

Curly Eyebrows

Like many eyebrows considered imperfect by the masters of Siang Mien, curly, circular ones intimate untidy and unsystematic thinking. They also suggest fickleness and a lack of true affection, for their owners prefer new relationships to established ones.

These eyebrows often go with a *prominent bone structure situated just above the brow*, in which case there is likely to be a setback in a career in the early thirties.

If the rest of the face is not good — that is, if there is a general weakness of the forehead and eyes, and of the chin in particular — this person is likely to die before age thirty-five.

Eyebrow Hairs Growing Down

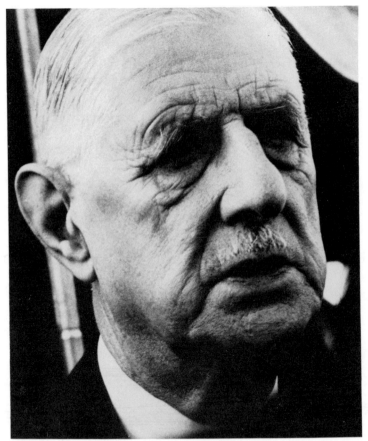

*Charles de Gaulle — Eyebrow hairs growing down,
dark (before graying) and thick*

Most eyebrow hairs grow upward. Those whose eyebrow hairs grow downward tend to be immature and at odds with friends, family, and often life itself.

If the eyebrows grow downward and are also dark and thick, these could well indicate a change of fortune for the better after age thirty-five, especially for someone who has chosen a military or political career. This is most likely if the face is a Jade or King face (described in Chapter 3, The Face Shapes).

Visible Roots

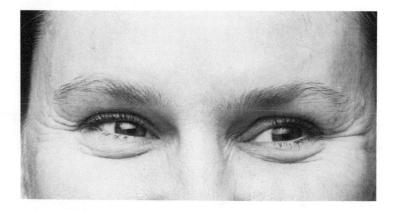

There are aggressive tendencies in everyone. Some people are able to use these to advantage, but others go through life as victims of their inner conflicts.

Those lucky enough to have eyebrows with visible roots can, say students of Siang Mien, not only cope with unfavorable reactions to their aggressive behavior, but, on occasion, they will even earn the respect of the victims of their aggression.

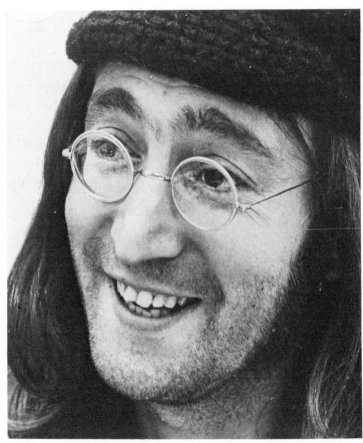

John Lennon — Eyebrows with visible roots

6

The Eyes

You cannot hide behind your eyes, only behind sunglasses; for it is the eyes that tell the world if you are powerful or trustworthy.

The eyes are very important to a thorough understanding of Siang Mien. In fact, instead of saying — as many of us would — that our ears burn if someone is talking about us, the masters of Siang Mien use the expression:

> Eyes that twitch, eyebrows grown long,
> Somebody's saying what you have done wrong.

Siang Mien shows that, in order to understand someone's eyes, it is as important to observe their gaze, or "look," as it is to study their shape.

This chapter examines:

The Gaze
The Shapes
Special Aspects of the Eyes
Color

But first comes a Siang Mien warning — that it is easy to be deceived by your own eyes. The warning comes in a twelve-hundred-year-old tale with a moral:

A man who lost his ax suspected his neighbor's son of stealing it. He watched the way the boy walked: just like a thief. He watched the lad's facial expressions: he looked like a thief. He watched the way he talked: exactly like a thief. In fact, everything the lad

did and said appeared to prove that he was the thief.

A few days later the man found his ax in a cupboard. When he saw the neighbor's son later that day, he noticed that the lad's gestures and actions were quite unlike those of a thief.

And so, Siang Mien reveals that a prejudiced glance is a hazard. Judging character requires an objective and thorough analysis of every detail of the face. It is the work of a practiced and unjaundiced eye.

THE GAZE

Powerful

Some people have such a direct, focused, and steady gaze that it seems to penetrate into the very minds of others. Some can outstare a cat.

In general, those with such a powerful gaze are able to assess other people and situations more accurately than those whose eyes are submissive, weak or watery, or not authoritative; although to be subjected to a hard or penetrating stare can be intimidating.

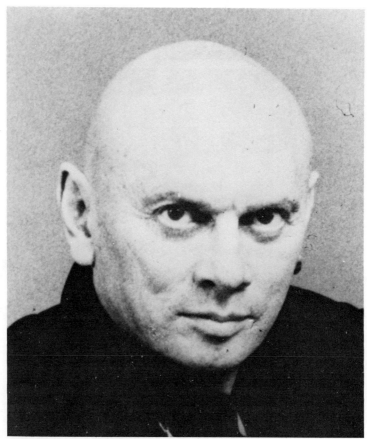

Yul Brynner — Powerful Gaze

Shifty

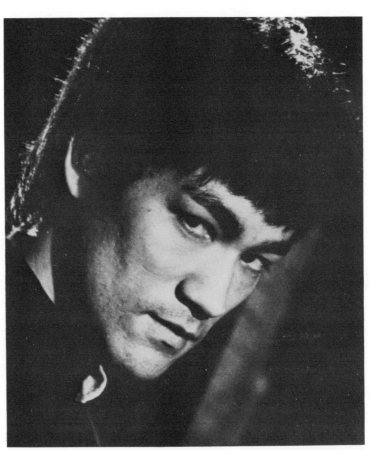

Bruce Lee — Shifty Gaze

Those with a shifty gaze have difficulty looking others in the eye, preferring to look at their feet, or anything else, to avoid eye contact. These people have something to hide. Some are also shy.

Shyness, according to Siang Mien, is linked to selfishness, because many "painfully shy" people are so involved with their own thoughts that they are unable to open their minds or eyes to the wishes, needs, or sometimes even the presence of anyone else.

Blinking

Some people blink a lot. This is sometimes caused by a temporary emotion, but frequent and habitual blinking is symptomatic of high-strung nerves.

Those whose eyes reopen slowly after each blink are less stable than most people, and where this action is especially prolonged, the cause is likely to be mental instability.

Open

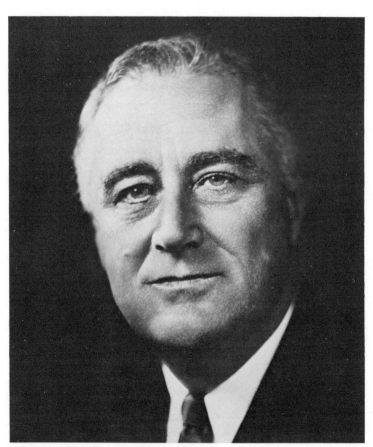

Franklin D. Roosevelt — Open Gaze

The open gaze is the best. Not only are the eyes clear, shiny, and sparkling, and therefore attractive, but they also possess all the good attributes of the powerful gaze, without its sometimes threatening and off-putting hardness.

Near- and Farsightedness

Siang Mien reveals that neither condition has any adverse effect on character or fortune, except in cases where a person is too proud or conceited to wear spectacles or seek professional advice.

There is a popular Siang Mien tale about this.

Two nearsighted men were too proud to admit their defect. One day they heard that a banner was to be hung in a temple, so each found out beforehand what would be written on it.

"Look," said one. "It says Brightness and Uprighteousness."

"The small writing under the large words includes the date," said the other.

A passerby asked what they were looking at. When told, the man said: "The banner hasn't been put up yet, so how can you read what it says?"

Siang Mien reveals an additional quality possessed by many nearsighted people: they are sensuous and imaginative in their lovemaking.

Sleepy

Sleepy Gaze

As the degree of power in the eyes changes with emotional and physical well-being, it would be misleading to assess people's characters from their eyes if, for instance, they had just spent the last eighteen hours on a jet coming from the other side of the world.

However, someone whose eyes are regularly sleepy and dull-looking is unlikely to be successful in personal relations or in a career. Such a person is indecisive and disorganized, so it is advisable when choosing partners in business or marriage to think twice if their eyes have a sleepy look.

Of all the types of gazes identified by Siang Mien, eyes that are so sleepy they look drunken are the worst.

People with *drunken* eyes are weak, unreliable, sometimes abusive, but worst of all, they retreat into

a dream world rather than face up to reality. Yet the world into which they retreat is far from peaceful because it is of their own making and is, for the most part, unhappy. They make disappointing friends and lovers.

Vacant

Vacant Gaze

We all look vacant at times — when we are deep in thought, wistful, or just daydreaming. Individuals who have this gaze all the time are unreliable, and afraid to make decisions. Although many with a permanently vacant gaze are perfectly pleasant people, marriage to someone with this gaze can be frustrating, especially for those who are decisive, energetic, or ambitious.

Sensuous

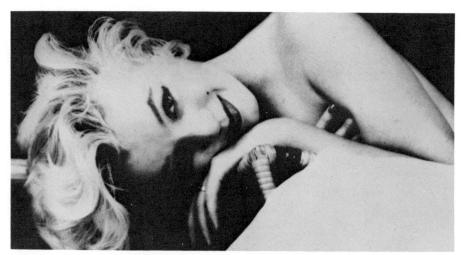

Marilyn Monroe and Omar Sharif — Sensuous Gaze

According to Siang Mien, anyone who has sensuous eyes has peach blossom eyes.

Chinese men are not fussed about being considered effeminate. What is in a name, after all, when peaches are synonymous with sexual success to the Chinese? More important to Chinese men is the wish to prolong their sexual activities as long as possible, so anything remotely connected with aphrodisiacs has popular appeal: ginseng root, many herbs, snakes, the antlers

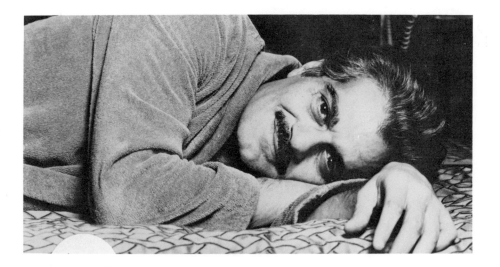

and tails of the northern China gray deer, and peaches because of their shape and texture.

Thus in Siang Mien very expressive and alluring eyes are called "peach blossoms" as a tribute to the beauty of the peach. Peach blossom eyes most resemble what might be called "bedroom eyes": they are shiny, expressive, and beckoning. They are the eyes of a great lover, someone who is terribly attractive to the opposite sex or, in some cases, the same sex.

Angry or Mad

Anger is reflected in the eyes and mouth, and some eyebrow shapes reveal angry dispositions. The eyes of someone roused to anger combine elements of dark fury, a steely glint, sometimes indignation, and often, cold hatred. Some eyes also bulge.

People whose eyes are always angry should be avoided. Many criminals have these eyes. Siang Mien reveals that anyone with very angry eyes risks an accident between the ages of thirty-five and forty.

Since the 1960s, a large number of angry men and women, dedicated to political causes, have made news headlines. Some are genuine revolutionaries who want to change the world. Many have eyes that express the disdain, intolerance, and anger they feel toward governments and social systems and the people who sup-

port them. These eyes sometimes look mad, at other times, angry. The look is very similar.

The masters of Siang Mien have never trusted the eyes of a fanatic, believing that their angry or mad gaze is more likely to frighten than inspire. And they have a cautionary message: Do not entrust your life, limb, or property, or those of loved ones, to the care of anyone whose eyes are mad or angry and whose eyebrows are also poor. (See also Chapter 5, The Eyebrows.)

THE SHAPES

Once you have begun carefully to study the faces of others and practice Siang Mien, it comes as no surprise to discover not only the range of different types of eyes, but also just how many people have eyes that differ one from the other. Such individuals will take characteristics from both eye types.

Dragon

The dragon, the most important beast to the Chinese people, was chosen by the emperors as their personal symbol of power. Not surprisingly, the masters of Siang Mien consider Dragon eyes to have the most powerful and beautiful shape of all.

Dragon eyes are large and have rounded lids and a well-curved lower rim. They are more elongated than Cow eyes, with larger areas of white

to the left and right of the iris. They indicate that their owner is innovative, with lots of ideas, some of which are good, others chancy, many hopeless. The Dragon-eyed person is good company, brave — without necessarily knowing it until put to the test — and usually generous.

Cow

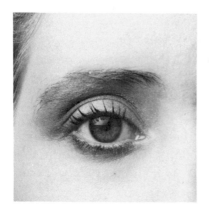

Cow eyes have rounded lids and curved lower rims like Dragon eyes. Smaller than Dragon eyes, they appear rounder because they are more compact.

People with Cow eyes are frank, but their direct manner sometimes causes offense. You know where you stand with Cow-eyed people. They are stubborn and have a capacity for hard work, their output dropping or poor only if they are unsuited to a task.

Peacock

Peacock eyes seem twice as long as they are deep (depth is measured from eyelid to lower rim). Siang Mien discerns two types of Peacock eyes, which may be called Peacock A and Peacock B. Peacock A eyes are longer and less slanted than the B type; the B type can slant up or down.

Peacock A eyes are associated with people who react emotionally to events and situations that do not appeal to them, or that they think are beyond them.

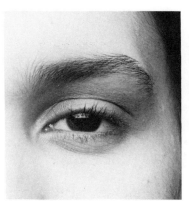
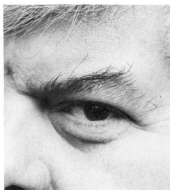

Peacock A *Peacock B*

They can be charmers, but if the object of their desires or needs — whether human or not — slips from their grasp, their jealousy or moodiness can be disturbing and unnerving.

Peacock B eyes have smaller areas of white on either side of the iris than do Peacock A eyes. People with Peacock B eyes have characteristics similar to those with Peacock A eyes, except that they are even more prone to jealousy.

Tiger and Fox

Tiger and Fox eyes give the impression of being as long as they are wide. The angles at the corners of the eye are less acute than in Peacock eyes. The possessors of Tiger and Fox eyes have good brains and satisfactory levels of intelligence. However, many are too lazy or timid to use these attributes to full advantage.

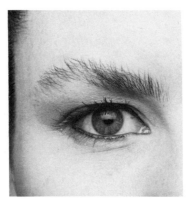 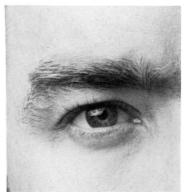

Tiger *Fox*

The Tiger eye is superior to the Fox eye because it is the larger of the two, and has a more generous area of white. People with Tiger eyes see ahead and set their sights on a quarry. They have staying power, and should make good civil servants, local government workers, or policemen, because, having identified their target or problem, they will persist until the job is done.

The Fox eye is a sign of native cunning and, in some cases, dishonesty. This does not mean that a Fox-eyed person is never to be trusted, because the whole face would have to be considered before such a conclusion could be made.

The villain in many traditional Chinese tales is a fox that operates in disguise, tricking and cheating good folk. The Fox eye in the Siang Mien charts is noted for its meanness, so it is not surprising that Fox-eyed people are ungenerous.

Triangular

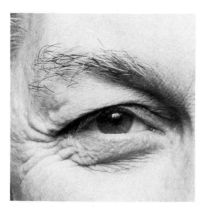

Pure Triangle

The larger of the two types of Triangle eyes is called the Pure Triangle and the smaller, the Chicken. Those with either type may feel — with reason — that not many people like them very much.

People with *Pure Triangle* eyes dislike anyone who opposes them or disagrees with their views. Many will brook no opposition under any circumstances, and with a single withering look — which could be said to resemble the hooded look of a crow — they can silence all comers.

These people are capable of using, even stepping on, others to achieve their ambitions. Some Siang Mien students say that Pure Triangle–eyed people have eyes at the back of the head, so wily are they at manipulating others. This eye is particularly good for anyone attracted to a political career.

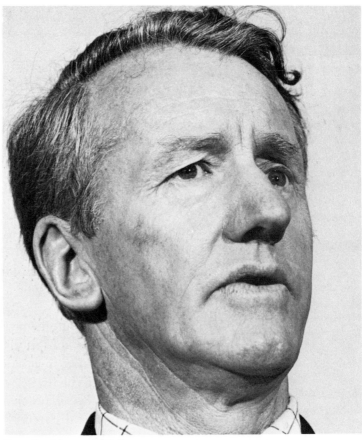

Ian Smith — Chicken eye

If the eyelid droops over the eye, this type of Triangle eye is known as the *Chicken*.

Siang Mien observes that Chicken-eyed people are nervy, persnickety, and appropriately, many spend a lot of time fretting and clucking around like hens. Many are interfering busybodies.

New Moon

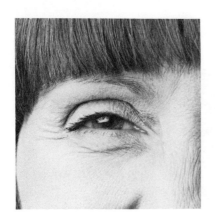

New Moon eyes are, alas, neither beautiful nor good. It is to be hoped that those with such eyes have other good facial features to counteract them, for New Moon eyes denote dishonesty to an even greater degree than do Fox eyes.

Generally, a man with New Moon eyes takes advantage of women or of anyone he considers inferior. Equally inclined to use people, New Moon–eyed women also enjoy brief sexual encounters (or would, if they dared), but will settle down to a long relationship if a partner satisfies them.

SPECIAL ASPECTS OF THE EYES

As well as types and shapes of eyes, the student of Siang Mien needs to look for a number of other salient factors, such as the eyelashes and the angle of the eyes in relation to the rest of the face. We begin with eye size.

Large and Small

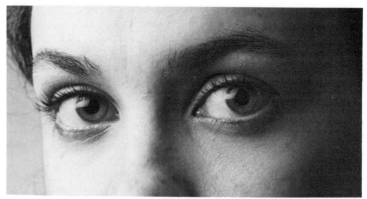

Large

Large eyes are better than small ones, for they are associated with happy people, who, though sometimes too impulsive and passionate, get more fun out of life than small-eyed people.

Small

Small eyes reveal that a person is uptight about too many things in life: too reserved, perhaps, or too conscious of appearances and of what others might say. Those who come to terms with these foibles can brush aside their natural reserve and caution to find that personal effort improves their lot in life.

Different Sizes, Different Levels

Different sizes

Those who have eyes of different sizes have fortunes that are uneven. Some years are very good, some poor, with a span of mediocre years before an upturn of fortune.

When one eye is higher than the other, emotional ups and downs govern the fortune. Siang Mien shows that this is also true of those with one eyebrow higher than the other. Individuals with either or both characteristics are tough on themselves, sometimes setting standards of achievement beyond their abilities. And

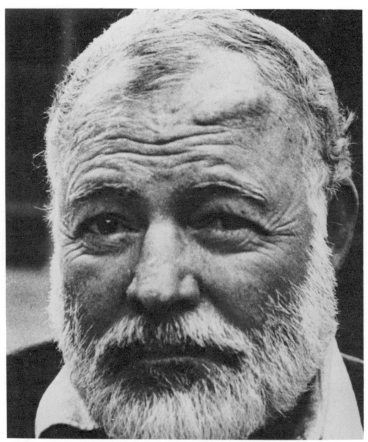

Ernest Hemingway — Eyes of different sizes

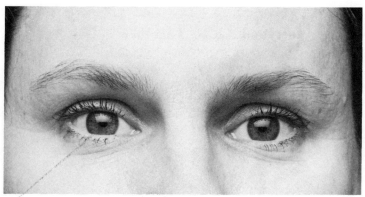

One eye higher than the other

so, instead of shrugging off bad patches or minor set-backs, as would most people, they overreact in adversity, blaming themselves for misfortunes beyond their control, and lack fighting spirit when it is most needed.

They also tend to daydream at inappropriate moments. Seeking to escape life's realities, they nevertheless experience many crises in their lives.

Wide Apart and Close Together

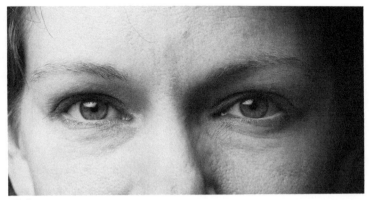

Wide apart

Eyes set wide apart provide a bird's-eye view of the world. This ability to see life in a broader spectrum gives those with wide-set eyes many opportunities de-

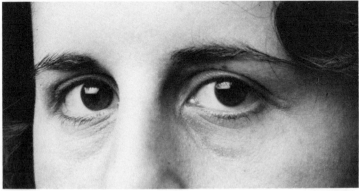

Close together

nied to other people, but not everyone with such eyes can make use of this ability.

There is a story first told in China more than two thousand years ago that became especially popular during the turbulent period of the Warring States.

An oyster was opening its shell when a bird pecked at it. The oyster clamped down its shell on the bird's beak and held on.

"If you don't open up there will be one dead oyster," said the bird.

"If you can't break away there'll be one dead bird," retorted the oyster.

A fisherman walked by and caught them both.

This ancient Chinese story shows how important it is to make the most of one's opportunities. Here, both the bird and the oyster lost out by not being able to see the long-range consequences of their inability to compromise. Siang Mien advises those with eyes set wide apart to use their greater gift of sight to advantage, and to grasp the significance of what there is to see.

Those whose eyes are set close together tend, like those whose eyes are small, to be reserved and conscious of appearances. Some are narrow-minded. Others are introverted, though they will deny it or not even realize that they are. Many such persons choose a career more suited to an extrovert in order to prove to themselves — consciously or subconsciously — that they are more daring and gregarious than they really feel.

Close-set eyes give an appearance of irritability that may be quite unjustified.

Slanting

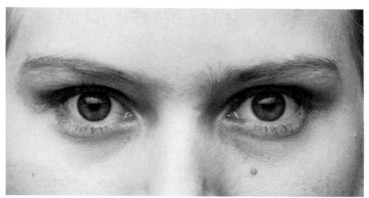

Eyes slant up

Eyes that slant *upward* reflect pride and optimism —
too much pride if the eyebrows also slope up.

Eyes slanting *down* indicate a rather cautious per-
sonality, someone who looks and thinks before leap-
ing. This characteristic is more evident if the brows
also slope down. Many pessimists have these eyes.

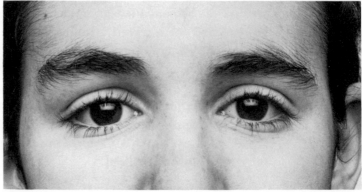

Eyes slant down

Deep-set

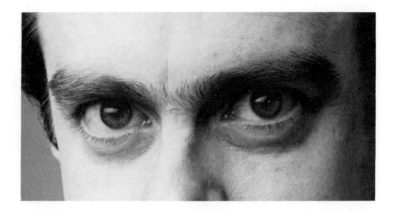

Siang Mien reveals that deep-set, or sunken, eyes belong to people who are withdrawn, secretive, or difficult to understand. Most of the time they have a tight control over their emotions.

Siang Mien advises one to be wary of those whose eyes are both deep-set and slit. If necessary, they will stab in the back anyone who comes between them and their goal.

Protruding

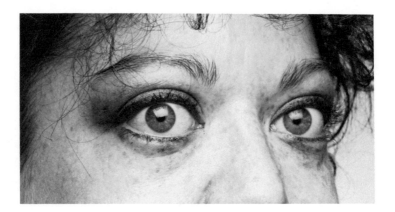

As we have seen in the Angry or Mad eyes section, eyes often protrude if a person is angry. Siang Mien students sometimes describe an extremely angry person as being "so angry that the hair stands up under the cap and the eyes bulge like those of the Yellow River fish."

Permanently protruding eyes, reveals Siang Mien, are a sign of hypersensitive emotions. If, however, protruding eyes are the result of a medical condition such as goiter, this reading does not necessarily apply.

Slightly protruding eyes are more acceptable to Siang Mien students, for they belong, in the main, to sociable people who can mix with strangers without showing self-consciousness.

However, Siang Mien has advice concerning protruding eyes: though often those with such eyes are good company, do not tell them secrets unless you want your secrets to become public knowledge.

Pointed Inner Tips

A lot of people have eyes with pointed inner tips. In many cases this is an indication of uneven fortune around midlife, which is likely to be caused by a member of the family who overspends or misjudges investments or savings.

Extremely pointed inner tips are a Siang Mien sign that an individual finds it difficult to concentrate. Some with such eyes are apt to fall asleep at inappropriate times.

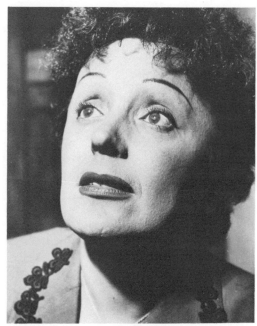

Edith Piaf — Pointed inner tips

Cross-eyed

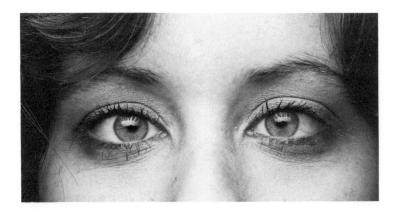

Finances are also threatened in midlife for those whose eyes do not focus on the same point. This is worthwhile information for anyone thinking of marrying a person with such eyes. Siang Mien would not go so far as to suggest that a marriage should not take place, but a Chinese proverb should be borne in mind: "A great fortune depends on luck, a small one on diligence." If your spouse-to-be disagrees with this proverb, it is obvious that he or she should not be given control of the family's purse strings.

Eyelashes

Long eyelashes

"Eyes cannot see their own lashes." The significance of this Siang Mien observation — obvious when you think about it — is the implication that people cannot see their own faults.

Though *long eyelashes* are rare in China, this did not prevent the early masters of Siang Mien or their disciples from admiring them for their beauty, nor from remarking that long lashes, though attractive, are frequently found on the faces of people whose emotions get the better of them.

Like most Chinese, the early Siang Mien masters and their followers abhorred public displays of inner feelings, including expressions of love or affection; thus, strict control over one's behavior in the presence of others was, and still is, expected at all times.

Very thick eyelash hairs add to any emotional instability that may be present, and *very fine hairs* suggest a cool disposition for most of the time, but those with such eyelashes can be ferocious if roused.

Eyelashes that *curl or turn up* without the aid of curlers or tongs signal optimism or passion.

Eyelids

Single eyelids

Although single eyelids are more common among the Chinese than in most other races, Siang Mien considers double eyelids superior.

Single eyelids may be taken as a warning that a person is coldhearted, even frigid, and such eyelids are associated with those who have difficulty forming lasting friendships.

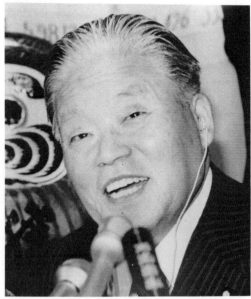

Masayoshi Ohira — Single eyelids

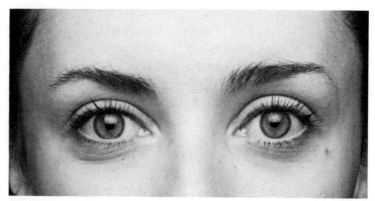

Double eyelids

COLOR

Black is beautiful. This is not a twentieth-century idea new to the Chinese, but an ancient Siang Mien disclosure that black eyes are synonymous with foresight, decisiveness, and immense intelligence.

Let us not kid ourselves, those of us with dark brown eyes. They may look black at midnight or on a dull day, but the test is in bright daylight; not many people have genuinely black eyes.

Dark brown eyes are superior to light brown eyes. They signify a loyalty toward the family, first as a son or daughter, later as a parent who will, if called upon, make sacrifices for the sake of the children.

Light brown eyes are associated with the ability to withdraw unscathed from unhappy and unsuccessful relationships. Those who have such eyes are not especially affectionate people. They may act in self-de-

fense and self-interest, and leave behind them a number of shattered people. Often they are unaware of the havoc or pain they have caused.

Intensely sapphire blue eyes, or *strong emerald green,* or *shiny mauve or gray* eyes are signs of an active mind. *Light blue, green, hazel, gray, or mauve* eyes are in no way inferior, but a person with pale rather than dark eyes is likely to have to work harder and dip into inner reserves of energy in order to be outstandingly successful.

Pale eyes *surrounded by yellowish "whites"* indicate a mediocre person susceptible to bouts of melancholy. A *circle of gray clouds* that forms around the gray eyes of a young person is a warning of poor health and poor fortune in middle age.

Eye Whites

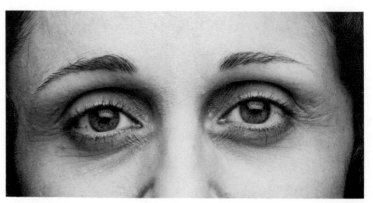

Two whites

The whites of eyes impart valuable information to those who understand Siang Mien. Most eyes have two

areas of white: to the left and right of the iris. But eyes with three or four areas of white tell the most.

Eyes with *three areas of white* have white on both sides of the iris, plus an area of white either above the iris or below it. Siang Mien advises against close friendships with anyone who has three areas of white.

While it is popular in the West to speak of "turning a blind eye" to something, the Chinese have an equally colorful expression: "to turn a white eye" against people means to disapprove of them and to criticize them behind their backs.

If the upper eye — that is, *above the iris* — is white, this reveals that a person is hypersensitive, takes offense easily, is self-centered and, if roused, quite brutish.

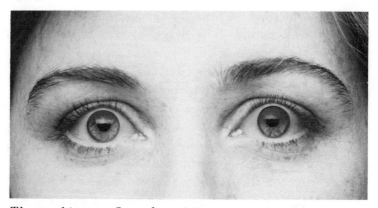

Three whites — One above iris

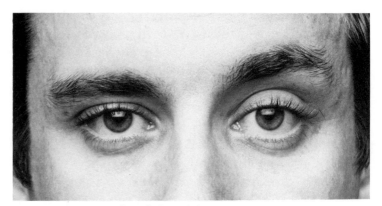

Three whites — One below iris

A person with white *below the iris* is oversensitive and tends to be self-conscious, but is more likable than someone with white showing in the upper eye.

With *four whites* showing, the iris is an island surrounded by a sea of white. Such people are so uncommon that you are apt to encounter only one or two in your lifetime. This is the eye of someone who is difficult to ignore. With a tendency to react scathingly when annoyed, those with four whites are bright, decisive, efficient, and good at managing people — the stuff of which executives should be made. But four-whites people are indeed rare, so less qualified people get many of the top jobs, a sorry tale for industry and commerce all over the world.

All those who have three or four areas of white are prone to accidents, and should take care of their health and observe balanced life-styles. This is not a Siang Mien directive to give up the good things of life or to become health fanatics. It is more important

that those with such eyes use their talents, but remember that they are unusual in many ways because of their eyes.

The masters have a postscript concerning the whites of children's eyes. If the whites of young people's eyes become *bluish*, this can be taken as a sign that something is worrying or frightening them, though they may not wish to let anyone know.

Finally, *red* eyes: this is a subject that has intrigued students of Siang Mien for centuries.

Eyes that are *obviously red* indicate that a person is high-strung, and likely to have a strong sex urge, often unrealized. Red eyes sometimes appear for short periods if there is too much fat in the diet.

Small *red dots that gather in clusters* in the whites of eyes are a reliable indication of an incipient sex maniac.

Red lines that run across, or through, the iris should be heeded as a signal that one is working too hard, and that pushing oneself to the limit will lead to overtiredness, carelessness, and the possibility of a serious accident or illness.

Similarly, *foggy or yellowish* whites should be heeded as a sign of strain. Siang Mien warns that the wise will take a break if this discoloration appears, and adds the challenging thought that, "even if you believe that the show cannot go on without you, no one, not even an emperor, is indispensable."

The Nose

If you ask the Chinese what good fortune means, the answer will be good health, good food, to be loved by the family and respected by young people when one is old. And last, but never least, money — and plenty of it.

It is the nose that reveals whether someone can make and retain money or not. According to one Siang Mien saying, "When your nose is itchy either you are tempted by the charms of someone, or you are tempted to spend money."

The early masters of Siang Mien identified many different nose shapes and singled out certain features, such as nostrils, for special consideration.

It should be borne in mind that, like eyes and mouths, noses sometimes differ according to race. For instance, Australian aborigines have wide, flat noses, and southern Chinese have flatter noses than Chinese from the north. Therefore, when practicing Siang Mien, make allowances for any racial features. You should estimate if the measurements of a nose that you are observing differ from a typical nose of that race.

The Best Nose

The best nose for money is one that is wide at the bridge, moderately large, and has a rounded tip supported by fleshy sides. The nostrils should not be visible when the nose is viewed full on.

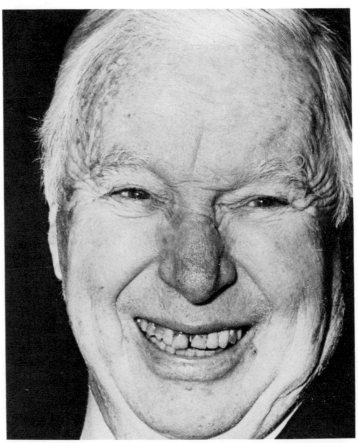

Charlie Chaplin — The best nose for making money

Those who have noses with a *very round, fleshy tip* are not particularly adventurous with money, preferring to invest it safely, or even to hoard it. Siang Mien considers round tips lucky for their owners; such fortunate people have artistic abilities and are reliably of honest intent.

A truly beautiful nose for making money not only has a round and fleshy tip, but also has *round, well-concealed nostrils.*

Arched

Unless another feature of the face is very bad, an arched nose indicates luck in life. The higher the arch, the more good fortune can be expected.

Straight

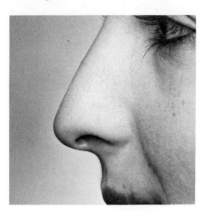

Straight noses are associated with good thinking. In fact, Siang Mien shows that those with a straight nose, plus a *thin nose tip, visible nostrils, and a good forehead* (smoothly rounded, wide, and deep), are especially suited to top jobs or anything that requires reliability.

Raquel Welch — Straight nose

Bumpy

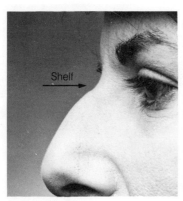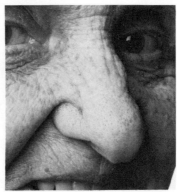

Roman nose *Nose with bumps*

Two types of bumpy noses are identified by Siang Mien.

One is familiarly known as a *Roman,* or *hook,* nose, although the ancient Siang Mien masters sometimes referred to it as the *shelf* nose. Having a shelf nose is desirable because those men and women who have this nose know how to look after their money — and how to conceal how much they have.

Those who have *one or more bumps* are faced with the prospect of financial worries, especially in mid-life. However, the masters of Siang Mien urge those with bumps to put their noses to the grindstone and work hard. That, they say, is the way to overcome most hardships — financial or otherwise — though success also requires one's fair share of good fortune.

Pointed

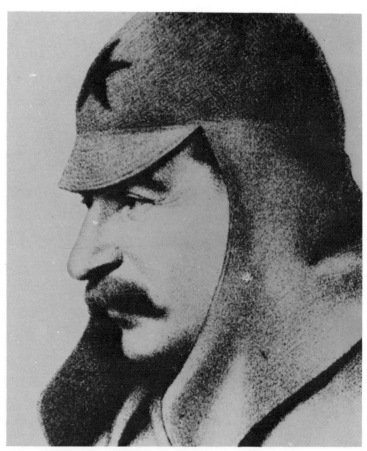

Joseph Stalin — Downward-pointing nose

Pointed noses are linked to a cool disposition, and the more the nose points down, the colder is its owner. To this is added a Siang Mien warning: an *extremely down-pointing* nose means that its owner is unreliable as a friend.

Eagle

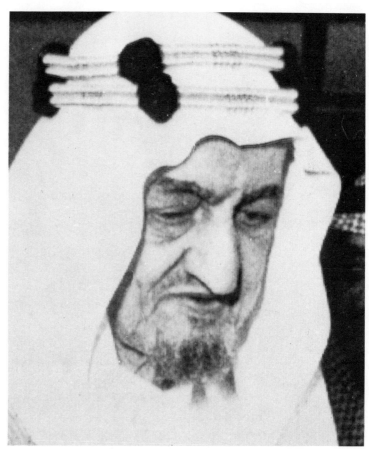

King Faisal — Eagle nose

The Eagle, or aquiline, nose is arched, and curves like the beak of an eagle. It denotes cruelty. "An eagle nose, a pockmarked face, no whiskers — with such do not associate," warn the Chinese. And a further warning comes from Siang Mien: unless those

with eagle noses overcome their cruel instincts, should they live long, they will be doomed to a lonely old age.

Crooked

 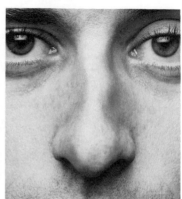

Crooked nose, round tip *Crooked nose, pointed tip*

A crooked nose is one defect linked by Siang Mien to the Irregular Face, one of the face types described in Chapter 3, The Face Shapes.

The masters of Siang Mien diagnose a crooked, or lopsided, nose as one that reveals a weak and emotional character. The nose tip is important here: a *round tip* on a crooked nose shows selfishness, while a *pointed tip* is symptomatic of nastiness and an inclination to use people for self-betterment.

There is a widespread Siang Mien belief that if the nose is crooked the owner's intentions are not upright. Rather mysteriously, but no doubt as a result of Siang Mien experience, it is claimed that those with lopsided noses who spent their childhoods in moun-

tainous regions are less likely to be weak, emotional, or selfish than those whose formative years took place elsewhere.

Long

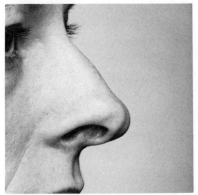

Long noses are indicative of stubbornness and self-pride that can, if exaggerated, lead to bad fortune and loss of friends. Some masters of Siang Mien observe that those with a long nose and *large nostrils* are mean and selfish, and should not be counted among one's close friends.

Long nose and large nostrils

Short

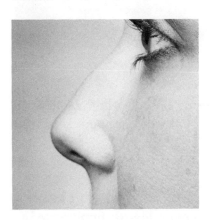

A short nose is linked by Siang Mien to periods of financial strain and a decline of fortune around middle age.

High

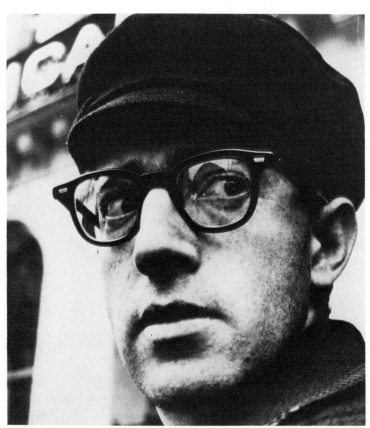

Woody Allen — High nose

A nose can be high without being either arched or Roman. A high nose is usually large, and is in the Siang Mien list of desirable qualities, for it indicates that the person who has it has fewer problems over money than most people.

However, a high nose that is also *long and narrow* betrays the fact that a person has difficulty saving

money. Add to this a *narrow bridge*, and the owner of such a nose should be alert to a decline in fortune from ages forty to forty-five, with a general improvement to look forward to after that.

Those who have a *high nose with a narrow, prominent bone* running down it are rarely afraid of solitude, and sometimes they crave it if their peace is threatened. They have to try harder than most to make a marriage work.

Greta Garbo — High nose and narrow, prominent bone

Flat

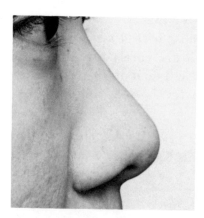

Flat noses presage personal prob-lems — sometimes arising from fi-nancial losses — in the mid-forties. However, most people with flat noses are not born rich, so they should learn to economize and use their money well before reaching forty.

"As a dry finger cannot take up salt," say the masters of Siang Mien, "so those with flat noses find it hard to accumulate wealth."

Childish

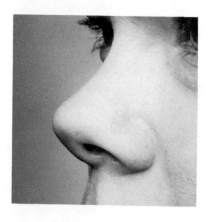

To many, this retroussé nose with its visible nostrils is pert or cute. How-ever, Siang Mien reveals that it is not a particularly auspicious nose as it signals moodiness, immaturity, and lack of the persistence or concentra-tion needed to complete a task.

Thin Nostrils

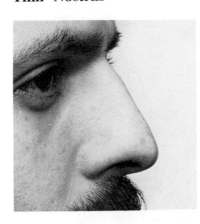

Like eagle-shaped noses, narrow openings to the nasal passages are indicators of loneliness in late-middle and old age. In some cases this loneliness occurs because one's children have gone away, rarely returning home. In other cases, friends have died or no longer call because they feel that the person with thin nostrils has changed.

Armed with this knowledge, those with thin nostrils or eagle-shaped noses who are still young or willing enough to change their ways can take steps to keep loneliness at bay by trying to understand other people better.

After all, counsel the Siang Mien masters, "those who do not believe in others find that no one believes in them." And to this may be added another Chinese maxim: "You can hardly make a friend in a year as you get older, but you can easily offend one in an hour." So, value your friends.

Not all thin nostrils are bad in the judgment of Siang Mien. Provided the *nostrils show* when viewed full face, even those with thin nostrils can be quite adventurous and may take a major risk or two in life. Too many risks, though, are unwise, warn the masters of Siang Mien, especially for anyone with thin nostrils who enjoys gambling.

"If you believe in gambling, be prepared for the day you will have to sell your house," they tell their students.

Plump and Thin

Mother Teresa — Plump nose indicating spiritual wealth

One's fortune is enhanced if the sides of the nose are full and fleshy.

Those with very narrow or sunken sides have to work harder than most to make a marriage succeed.

Aristotle Onassis — Plump nose indicating worldly wealth

Thin nose with sunken sides

One of the problems in marriage for those with thin noses is money, the destroyer of many good relationships. For anyone for whom this problem is real, the masters of Siang Mien quote the words of the ancient Chinese: "Those who know they have enough are rich," and, "It is harder to be poor without murmuring than to be rich without arrogance."

8

The Mouth

The part of the face that can get us into deepest trouble is the mouth, and there are a number of Siang Mien sayings that show how careful we must be.

- Much mischief comes from opening the mouth.
- Once a word has left the lips the swiftest horse cannot overtake it.
- His mouth is honey, his heart a sword.
- A sharp mouth can overturn home and country.

The last was said by Confucius to his disciples, and he added: "I wish I could do without speaking." But if he had, the world would have been robbed of some of its most famous sayings.

As it was, Confucius never conversed while eating, nor when in bed. He would not eat anything that might cause bad breath, nor food that was overcooked, undercooked, out of season, or underflavored.

By looking at the shape of the mouth and its size, and by listening to the words that issued from it, Confucius and the founding fathers of Siang Mien could measure how much confidence they could place in people. There are a number of qualities to look for when studying a person's mouth.

The Best Mouth

Peter Martins — The best mouth

> Your mouth is big, that's luck for you
> For happiness hangs from its corners, too.

Indeed, the best mouth is, as this Siang Mien ditty shows, large. Not only should it be large, but it has

to have a clear, distinct shape with corners that slope up. Each lip should be a quarter of an inch wide, and where the lips meet there should be a *straight, horizontal line.*

The straighter the horizontal line, the more a person can be expected to keep promises. Siang Mien, however, advises those with this mouth: others expect you to keep promises, so do not let them down.

This perfect mouth inspires confidence in others, and its lucky owner can communicate more easily with others than can those with inferior mouths. Anyone with this mouth can expect a reasonable standard of living.

It is noticeable to anyone who practices Siang Mien that those with *big mouths* forget problems more quickly than those with small mouths. They cope better in adversity, while those with *small mouths* are less inclined to turn to others for help or advice, often preferring to bottle up the problem.

For those with small mouths there are some compensations. Siang Mien shows that a woman with a small mouth is more easily satisfied in lovemaking than one whose mouth is large. This is especially so if her fingers are short.

A small-mouthed man, too, need not bemoan the shape of his mouth, for Siang Mien reveals that he is, or could be if he tried, an inventive and appealing lover.

We have seen that Siang Mien specifies a quarter of an inch to be the ideal width for each lip. Yet, *a lip wider than a quarter of an inch* is an indication of sensuality. One must remember, however, that many races and tribes characteristically have thick

lips, so if one is practicing Siang Mien among them, these racial factors should be taken into account. *Red lips*, Siang Mien shows, are a further indicator of sensuality. Again, it should be borne in mind that among races with *brown or black lips*, the shape and size of the mouth become more important considerations than color, as does the clarity of the outline of the mouth as distinguished from the rest of the face. A large, well-defined mouth reveals passion.

One Lip Thicker Than the Other

Many people have one lip that is thicker than the other.

Siang Mien warns that a *thicker upper lip* is a sign of deviousness, and that its owner should be treated cautiously. Many who have a thicker upper lip also have a glib tongue and are skillful in argument.

Those with a *thicker lower lip* find it difficult, at times, to inspire trust. This is especially the case if the person's eyes have a shifty or weak gaze.

Thicker upper lip

Thicker lower lip

In particular, those with a thicker lower lip who are aware of their shortcomings can turn to advantage their naturally good command of speech to try to entertain others. This may be on a purely personal level at parties or private events, though many professional artists and entertainers have this type of mouth.

*Noël Coward — Thicker
lower lip*

Receding Lower Lip

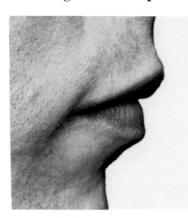

Those whose lower lip recedes cannot depend on help from outsiders. Confucius had a suitable rule of conduct to make up for this disappointment: "Those who are noble seek what they want in themselves, but inferior people seek it from others."

Thick Lips

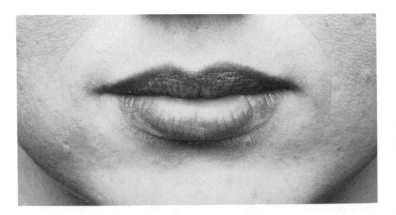

Thick-lipped people are more likely to be sensual and emotional than those whose lips are thin. It is generally felt by those who practice Siang Mien that some-

one whose mouth is shaped like a pyramid and who also has thick lips is especially susceptible to emotional fluctuations.

Thin Lips

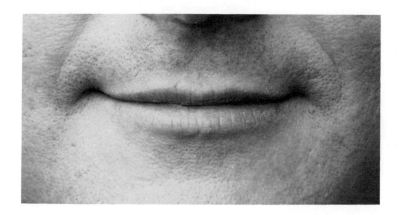

Exceptionally thin lips are a sign that their owners are brutal, and some with these lips even enjoy humiliating others. As one would expect, they are selfish and emotionally cold. All these unattractive traits are tempered if the *tip of the nose is round,* rather than pointed.

In Siang Mien this mouth is associated with fussy eating habits and a general wariness of new foods.

The Wavy Line

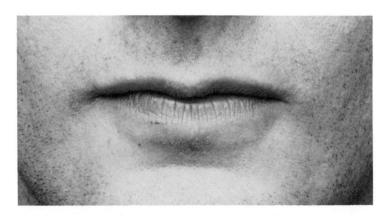

If a wavy line forms where a person's lips meet, that person is quietly confident with words and, if called upon to address a gathering, could do very well as a public speaker. However, not even the gift of gab is enough to ensure financial stability at all times.

Apart from this financial limitation, those with this mouth are more reliable than most, and others can feel confident in their presence.

Protruding Teeth and Visible Gums

The early masters of Siang Mien had differing opinions about the significance of protruding teeth, or gums that are visible when a person smiles. Even today there are two divergent interpretations. Contradictory though they are, each contains a clear message.

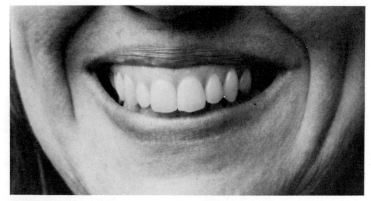

Visible gums when a person smiles

This mouth belongs either to a very generous person or to a very mean one. Siang Mien adds two paradoxical dicta:

> To be too generous arouses the suspicion that
> one is buying favors and praise.
> Yet to be mean invites great unhappiness in
> the last years of one's life.

You will also find that many people with visible gums veer from periods of generosity to bouts of stinginess.

The Corners of the Mouth

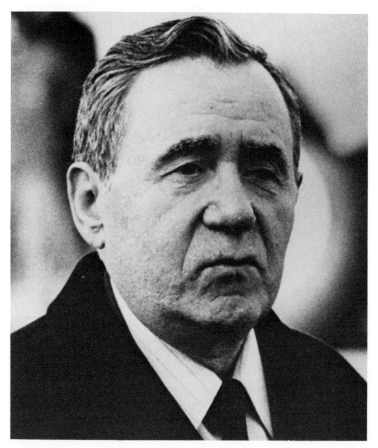

Andrei Gromyko — Turned-down mouth

A mouth that *turns down* denotes that one is oversensitive, pessimistic, and, at the very worst, a killjoy.

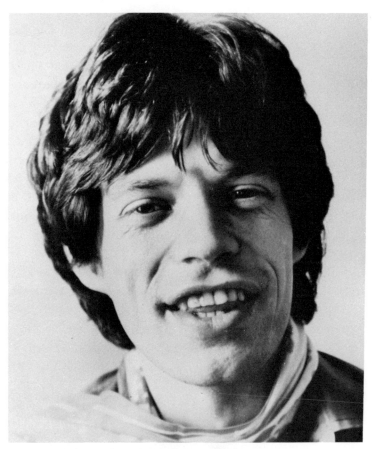

Mick Jagger — Turned-up mouth

As would be expected, a mouth that *turns up* reflects happiness and optimism. Naturally, those with such a mouth have gloomy periods from time to time, but for them life is to be lived, and the more enjoyment they can get out of it, the better.

The masters of Siang Mien remind us that "with happiness comes intelligence to the heart, and those who are happy do not notice how time goes by." To this they add another judgment: "The contented man, though poor, is happy. The discontented man, though rich, is sad."

There are some mouths whose *corners recede into tiny hollows.* Siang Mien detects immediately that those with this mouth strive to compensate for a lack of self-esteem and a feeling of inferiority through what might appear to an untrained observer as aggressive behavior, impatience, or a supercilious attitude — all indicators of a personality problem.

Tiny hollows at corners of mouth

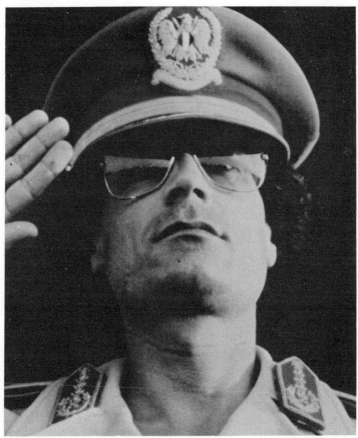

Muammar el-Qaddafi — Tiny hollows at corners of mouth

Crooked Mouth

Whether or not you have a crooked mouth, Siang Mien would advise you to note the following Chinese story.

While hunting for a meal, a tiger caught a fox.

"You can't eat me," said the fox, with a cunning, crooked smile. "The Emperor of Heaven has appointed me king of the beasts. If you eat me you will disobey his orders. If you don't believe me, follow me. You will see that the other animals will run away at the sight of me."

Agreeing to this the tiger let the fox go, and followed him through the forest. When all the beasts saw them coming they dashed away. The tiger, not realizing that they were afraid of him, thought they were afraid of the fox.

A crooked mouth is a Siang Mien symbol of dishonesty and deceitfulness, but not all those with crooked

mouths have the natural cunning of a fox. If some-
one's mouth becomes crooked through an illness, none
of these factors is valid.

Teeth

> The tongue is soft and remains;
> The teeth are hard and fall out.

Teeth are not easy to interpret, even for the masters
of Siang Mien, because personal and national eating
habits vary enormously, and diet can play havoc with
one's teeth. Those who nibble bones, or attack tough,
sticky toffees, or grind their teeth in their sleep are
liable to break or wear them down, making it difficult
for the student of Siang Mien to identify naturally
inferior teeth from damaged ones, and real teeth from
false. In these days of modern dentistry, one can
never be sure if teeth are crowned, giving their owner
a better set than the original. Nothing can be told
about character, fortune, or personality from false
teeth. For this, one needs the real thing.

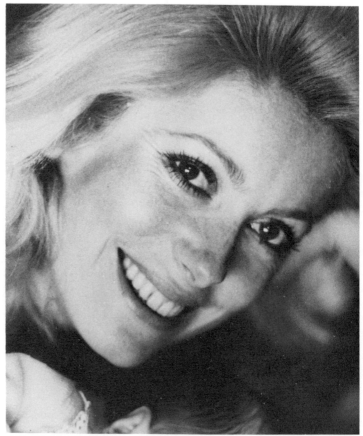

Catherine Deneuve — Good teeth

A set of *well-arranged, evenly shaped* teeth that remain *free from major defects* (such as decay and discoloration) signifies that its owner learns more quickly than most. This is especially true if this person also has a *fine forehead,* that is, one that is high, smoothly rounded, wide, and deep.

Small teeth

Long teeth

Good teeth are *large,* rather than *small. Long* ones mean a long life.

François Mitterand — Gaps between teeth

The masters of Siang Mien disagree with the Western idea that *gaps* between the teeth symbolize good luck with money. On the contrary, they argue, nicely arranged teeth bring greater fortune than gappy ones.

Teeth varied in size

No matter how "good" — by Siang Mien standards — a face is, fortune is diminished if the teeth are *too variable in size*. If, for instance, the *two top front* ones are large, their owner is too stubborn. If one of these *falls out* from an adult's mouth, that person's fortune will not be good for a year.

If both the upper and lower rows *slope inward*, be warned, say the masters of Siang Mien, that this is an erratic and unpredictable person.

Thick, ivory-colored teeth generally belong to excitable people, while *thin* teeth and *very white* ones betray a fickle friend.

The Jen-chung

This is the Siang Mien name for the groove situated between the base of the nose and the middle of the upper lip.

Jen-chung wider at bottom

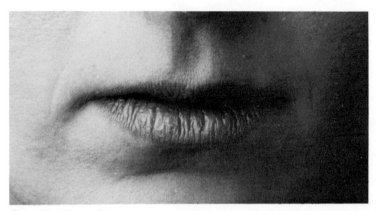

Parallel Jen-chung

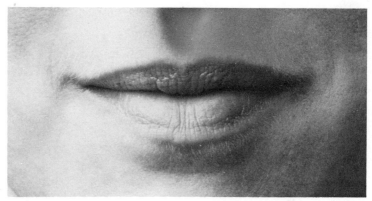

Jen-chung wider at top

If it is long, its owner will live long. The early masters of Siang Mien had a theory that an inch represented one hundred years, and today some followers of Siang Mien maintain that the Jen-chung indicates whether or not one will become a centenarian.

In recent times, the theory has developed that certain Siang Mien facts about happiness and family relationships can be told from the Jen-chung.

Siang Mien reveals that those with a Jen-chung that *widens toward the bottom* had periods of conflict or doubt in an unsettled childhood, which still affect them throughout their adult life.

The Jen-chung that is the *same width from top to bottom* — like two parallel vertical lines — indicates a long life and a firm and determined character, capable of inspiring a sound family tradition.

The Jen-chung that is *wider at the top* belongs to those who find life more difficult and problematic with the passing years. Early promise proves difficult to fulfill, and some hopes are never realized.

The Ear

In the southwest of China in the year 220 lived a man called Liu Pei. At this time the country was divided into warring states to the north and south of the great Yangtze River. Claiming descent from the royal family of Han, Liu Pei founded a new dynasty and prepared his followers for war.

Liu Pei has fascinated students of Siang Mien for centuries for he is reputed to have had huge ears like an elephant's, ears that reached to his shoulders. In modern times the Masai tribe of Kenya continues the custom of stretching their ears by attaching metal weights, glass beads, or wooden disks to their lobes, some of which stretch to four inches in length.

No one knows whether or not the story about Liu Pei has been exaggerated, but ideally, say the Siang Mien masters, the ears should be large and rather soft.

The first books written about Siang Mien contained drawings of people with ears that stretched not only to the shoulders, but also to the ground. Almost all these books were destroyed in China's turbulent past when palaces were frequently sacked and their libraries of precious books burned, but writers of the Ming dynasty referred to these records of ideal ears of extreme length.

The ears govern the period from a person's birth to the age of fourteen. Siang Mien cannot be practiced with reliability on the face — still changing and developing — of anyone under fourteen, so ears are

the most positive source of information for that age.

You will be amazed to discover, when you examine them seriously, that ears are as individual as fingerprints. It follows that the amount of information obtained from them is astonishing. Successive generations of masters and students of Siang Mien have put together some important particulars about the ear, including the relation of the lobe to one's sex drive.

Size and Position

The ears now considered by Siang Mien as most auspicious are still *large* ones. However, it is no advantage to have large ears that are disproportionate to the size of the face. *Large ears on a small face* betray a lack of substance and a shallow character. Yet, these people are lucky in that others like and readily help them. Despite the assistance and opportunities that come their way, those with large ears and small faces find it difficult to grasp and hold on to power.

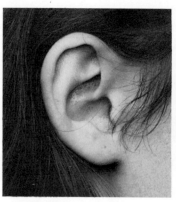

Small ear *Large ear*

Pope John Paul II — Well-proportioned, large ears

Small ears inform Siang Mien observers that their owners are men and women who work hard, unable as they are to rely on support from others. Though these people are ambitious, a lack of confidence can cause a gap between what they want and what they can achieve.

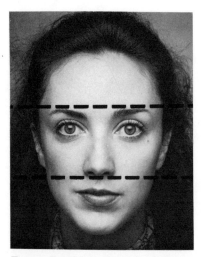

Ears should be between the two lines

The simplest way of telling whether or not people's ears are well positioned is to draw two imaginary, horizontal, parallel lines through the eyebrows and the tip of the nose. For good fortune throughout one's life a person's ears should lie entirely between the two lines.

The chances of being famous before age thirty are increased if the ears *extend above the line of the eyebrows,* but this is no guarantee that good fortune or wealth will last forever. Those who hope for fame and success would be well advised to bear in mind what Confucius had to say:

"Those who are wise are not distressed that people do not know them; they are distressed at their own lack of ability."

Those with *low-placed* ears are likely to achieve most late in life. The extent of their achievements can be told from the lower part of the face, particularly the chin (see Chapter 11, The Chin).

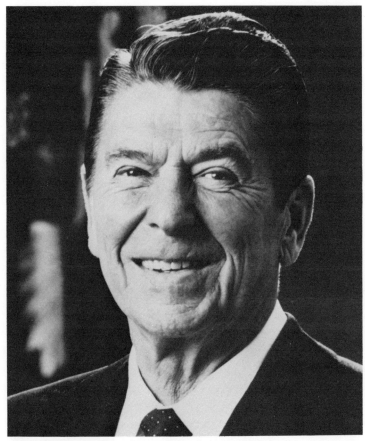

Ronald Reagan — Low-placed ears

Shape

Flat ears

Ears should be *flat,* an indication of good fortune and stable family relationships. There is a Chinese belief that if an ear is so flat that a finger cannot fit anywhere behind it, this person will live beyond eighty.

Many people have *protruding* ears. However slightly ears may protrude, they still indicate that their owners need to draw heavily on inner reserves of strength and ability to get on in life.

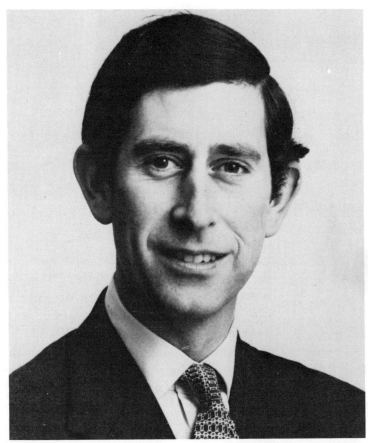

Prince Charles — Protruding ears

 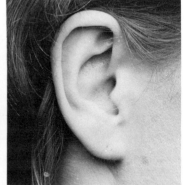

Round ears *Squarish ears*

Besides being flat, the best ears are also *round*, declare the masters of Siang Mien. Round ears denote wealth and kindness, while ears that are *squarish* — also considered desirable by Siang Mien — contribute to a person's wealth and cleverness.

Those with *long* ears instinctively help only those who deserve help, and uncannily sense when someone is trying to take advantage of them.

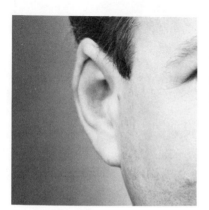

Pointed tips — upper or lower, but especially upper ones — inform the Siang Mien observer that those with these ears are more stubborn, and generally more efficient and conscientious in what they do, than most.

Pointed ears

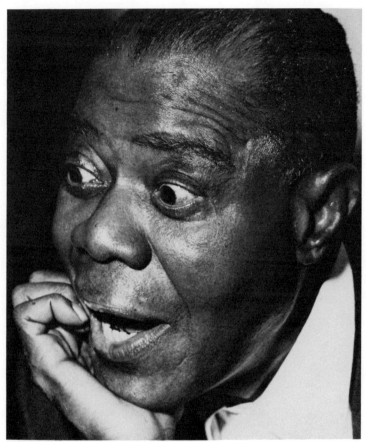

Louis Armstrong — Thick ears

Thick ears are more desirable than *thin* ears; thick ones contribute to good fortune; thin ones are associated with physical weakness and periods of indifferent health.

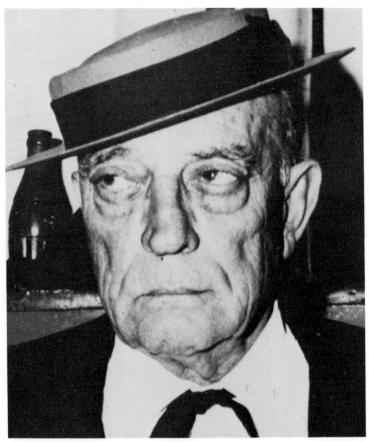

Buster Keaton — Ears markedly wider at top

An ear that is *markedly wider at the top* than at the lower half can tell a Siang Mien student that its owner excels in one particular endeavor or subject.

Outer and Inner Circles

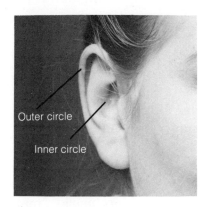

Outer circle

Inner circle

Siang Mien divides the ear into visible outer and inner circles. Those who are blessed with a large and well-shaped ear (round, smooth, soft, thick), plus well-defined inner and outer circles, can make a success of most things they set their hearts on.

Those whose inner circle is more prominent than the outer circle have stamina, and will see through any project, scheme, or task they set their minds to.

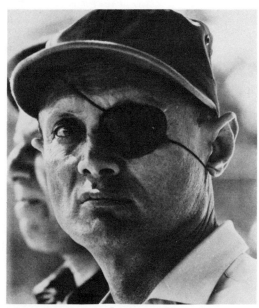

Moshe Dayan — Ear with prominent inner circle

A bend on the outer circle

If the ear is comparatively large, but the inner circle is not well defined (or is lower than the outer circle, or receding), then this person should not expect to advance very high up the executive ladder unless the forehead is so good (round, smooth, high, wide, and deep) that it compensates for the ear.

If the inner or outer circle, or both, sticks out to form a *sharp corner or bend* on its perimeter, an unhappy event that took place between the ages of three and four has left its mark. Naturally, few will ever discover the circumstances of this, but as a result of it, persons with this ear characteristic take things for granted, and their lack of gratitude can severely harm relationships.

Lobes

Small lobe with a round, wide inner circle

The lobes tell the Siang Mien observer something about a person's love life.

Small lobes are telltale signs that insecure relationships with parents or elders have caused emotional blocks or hang-ups that affect the enjoyment of sex.

The problem is lessened if the inner circle of the ear is round and wide. In fact, this combination of a *small lobe with a round and wide inner circle* tells the Siang Mien ob-

server that here, indeed, is someone with a strong sex urge.

Add to this a round outer ear, and the owner is not only interested in sex, but liable to prove much too lusty for all but those who have the same type of ear!

Tiny lobes on round ears allow Siang Mien observers to identify a fairly stubborn person fond of material comforts.

The best lobes are *large and thick,* for nice fleshy

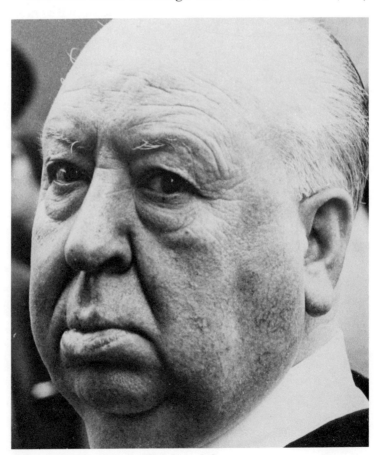

Alfred Hitchcock — The best lobe

lower ears are a sign of fortune and ability to accumulate more than average wealth. Even those who are unable to save money because of a poorly shaped nose (see Chapter 7, The Nose) can reap some benefit from having good earlobes. According to Siang Mien, having good lobes not only brings good fortune, but also is the key to having links with people who can help.

This, say the Siang Mien masters, is like being the rich man who asks a favor and is invited in, made to feel welcome, and supplied with more than he requested before being sent happily on his way. On the other hand, if a poor or unlucky man asks the same, he is scorned and treated like a thief.

If the lobe *protrudes and slants toward the mouth*, this indicates that fortune will improve late in life.

Immediately above the lobe, the inner circle dips down to form a *notch*. The more generous a person is, the wider the notch. It should comfortably accommodate your forefinger if you have a free and easy attitude about giving. A tighter fit shows a more penny-pinching attitude.

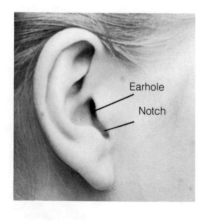

Above the notch is the *earhole*. One that is *tucked away deeply* at the back of the ear and is difficult to see belongs to a person with a probing mind, while a *small, shallow* earhole belongs to one who is not especially interested in other people.

A *wide* earhole is associated with argumentative people, who do not easily believe what others tell them. The masters of Siang Mien quote

Confucius to these people: "If you are disliked at forty, so you will be to the end." A fair warning, but one that those with wide earholes are likely to disregard.

Hairy ear

Some people are naturally more hairy than others. If there is a *heavy growth of hair* in the ear that is disproportionate to hair growth on the rest of the body, this communicates to the Siang Mien onlooker that these people waste their talents and dissipate their energies.

The masters of Siang Mien conclude their observations of the ear by linking it to the eyes and heart. "When the ear will not listen, the heart escapes sorrow. But when you have heard, you must heed; when you have seen, you must judge in your heart."

Cheeks and Cheekbones

According to popular opinion in the West, the most attractive cheekbones are *high cheekbones*, which are thought to enhance a woman's beauty.

This is not the Siang Mien concept of good cheekbones. For one thing, say the masters of Siang Mien, "those with bones sticking out under the eyes" have hollow, or even sunken, cheeks. They look lean and hungry and they age prematurely, so that by the time they are forty, or thirty-five in some cases, they look older than they are, while those with *plump cheeks* often look years younger than their true age.

The Siang Mien ideal of beautiful cheeks and cheekbones is a slightly *rounded* look in which skin and bone are well balanced. The masters of Siang

Queen Victoria and Mao Tse-tung had one thing in common: plump, rounded cheeks

Mien could turn to China's most famous novel to illustrate their point.

The Dream of the Red Chamber was written in the eighteenth century, and to weave his story of love and fiendish family intrigues, the author used no fewer than 421 characters — 232 males and 189 females. In one scene a young girl describes her first impressions of a handsome man: "His clothes were shabby, yet he was powerfully built with an open face, firm lips, eyebrows like scimitars, eyes like stars, a straight nose, and rounded cheeks."

Rounded cheeks are prized because they reveal that their owner has more command of power than does someone with high cheekbones or *lean, low, or flat* cheeks. People will think twice, maybe more than twice, before trying to take advantage of those with rounded cheeks.

Siang Mien has yet more good words for rounded cheeks. It likens them to peaches: round, smooth, and pink. One of China's greatest poets, Li Po, wrote, in the eighth century, of a sailor's aging wife:

> Pity me now; when I was fifteen
> My face was as pink as a peach's skin.

Today, doting grandmothers in China can be seen cuddling their small grandchildren and playfully nibbling their bright pink cheeks, which they call "peach cheeks." Biting peaches constituted a large part of the day's work for Monkey, a favorite Chinese mythological character, who, like the Chinese themselves, believed that peaches contain the secret of immortality.

"It is better to take one bite of peach than to eat a basketful of apricots" is the Chinese way of saying

that a little of the best is more desirable than a lot of something inferior.

Siang Mien provides additional information for those with *dark skins* for whom pink cheeks might well be irrelevant and unimportant. Rounded cheeks are still the best, but they are perfect if the skin on the cheekbones *glistens*. As with pink cheeks, people will not readily try to get the better of those with rounded cheekbones and dark, glistening skin.

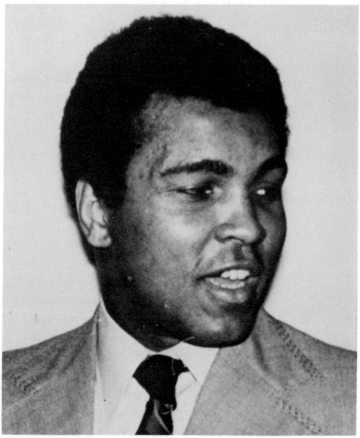

Muhammad Ali — Glistening, rounded cheeks

So far, all the praise from the masters of Siang Mien has been for rounded cheeks. There is, however, some compensation for those with prominent cheekbones.

If the *cheekbones are the widest part of the face*, this means that their owner is good at tackling matters that need attention, and that the job will be done, even if it takes a long time. Those with *wide, prominent cheekbones* do not have a large number of close friends, in part because others are jealous of them, in part because others cannot resist criticizing any decision or action that those with prominent cheekbones take.

As is stressed in all Siang Mien teaching, one particular feature should never be considered in isolation. This is especially important with high cheekbones.

For instance, Siang Mien selects three important ingredients that those hoping for a successful career in the armed forces should possess: *prominent cheekbones, sunken cheeks, and a strong jaw*.

Yet, *prominent cheekbones combined with a very pointed chin* indicate someone who lacks the affection and faithfulness needed to be a true friend.

Sharply defined, high cheekbones that slant upward belong to those who see themselves as the dominant figure at home. At worst, they will make use of friends, and sometimes their families, to achieve their goals.

Another important Siang Mien observation concerns those who have both *high cheekbones and severely sunken cheeks.* They can expect their fortunes to take a tumble sometime during the period from

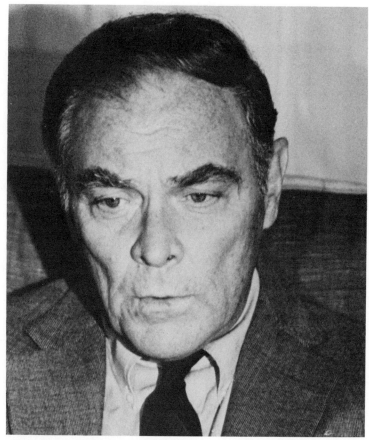

Alexander Haig has the three important ingredients of a successful soldier's face

ages thirty to fifty. If, say the masters of Siang Mien, the severely sunken cheeks are caused by ill health, one should seek the type of medicine or treatment for which the body has an affinity. If the sunken cheeks are caused by dieting and vanity, then, say the masters, no medicine can cure a vulgar or foolish person.

Low, flat cheekbones

Low, flat cheekbones deserve a separate comment. The masters of Siang Mien observe that this type of cheekbone conveys a tendency to acquiesce, and an inclination to sidestep a challenge or conflict. *Very flat* cheekbones betray humility and cowardice.

The masters urge these people to think about the Chinese suggestion that "wise people make their own decisions, while foolish ones follow public opinion." To this they add the tale that is told to a frightened child:

In the jungle the tiger and the leopard are afraid to meet the unicorn, and even the mighty dragon is scared of something: the centipede. Just as some people fear moths, spiders, or little lizards, so the dragon has his phobia, too.

All of us — even the most powerful — one day meet someone of whom we are afraid.

One way of telling if someone has been disappointed in love, especially in marriage, is to look at the *small areas of the cheeks* an inch immediately be-

Sunken areas under the eyes denote disappointment in love

low the inner corner of the eyes: these areas just beside the nose will be slightly sunken.

The masters of Siang Mien comment on *a line* that runs from the inner tip of the eye (by the nose) across the cheekbone. This is hardly auspicious, for it indicates one or more of the following: of disharmony at home during the period from thirty to fifty years (of age, not marriage); difficulty in retaining money; instances of being used by others to further their ambitions or desires.

However, Siang Mien urges those who have this line not to suspect that everyone they know or meet is out to get the better of them. On the contrary, say the Siang Mien masters, to know is to be forewarned, and their advice is simply: "Let your practice keep step with your knowledge."

Line across cheekbone

11

The Chin

When the first emperor of China died, he was buried in an enormous underground chamber constructed by more than seven hundred thousand laborers. Artisans fixed automatic crossbows so that any grave robbers who broke in would be slain. The emperor's childless concubines were buried with him, and to prevent those who were closely acquainted with the contents of the tomb from revealing what they knew, they, too, were buried.

As if this were not enough, an army of more than seven thousand life-size pottery figures of armored soldiers, crossbowmen, spearmen, charioteers, horsemen, and horses and chariots were buried in military formation in another chamber. This army was to protect the emperor on his journey to the next world.

The emperor, Ch'in Shih Huang-ti, is best known outside China as the builder of the Great Wall of China. In 1974, nearly twenty-two hundred years after his death, the pit containing the pottery army figures was discovered and excavated.

No two faces of the pottery men are identical, for they were modeled on individual soldiers from throughout the Ch'in empire. As one would expect of a nation that discovered Siang Mien, each soldier has a strong, virile face, most evident in the powerful nose and strong chin.

It is to the chin that one looks in order to discover what kind of old age a person will have, for the chin holds the secret of the years from fifty until the angels sing.

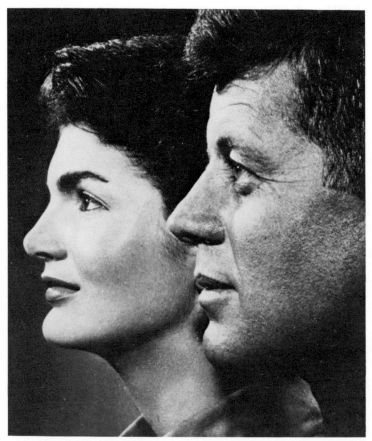

John F. Kennedy and his wife, Jacqueline — Hers is the more powerful chin

The most powerful chins are those that *stick out*. The weakest are those that *recede*.

A good chin is a *smoothly curving, round* one that forms part of a smooth, strong jaw. Together they symbolize a nice, comfortable old age.

Square chin

There is nothing inferior about a *square* chin, either. It, too, represents power plus the additional quality of leadership skills: those with square chins are better suited to be leaders than subordinates.

Those with *round or square* chins are most likely to live longest. Anyone with a *wide jaw* can also look forward to a good life span, provided the chin is good.

Round chin

Receding chin

Siang Mien has additional observations about *receding* chins. The people with these chins are less ambitious than most; they do not stretch themselves to their mental or physical limits. Siang Mien also reveals that, though some people with receding chins coast along through life and enjoy a reasonably good middle age, there is a likelihood of a dramatic change of fortune in later life, which will require a strong will to overcome problems affecting health and finances.

The chin also provides a useful yardstick for employers. Look here, say the masters of Siang Mien, if you are thinking of going into business with someone. A *full, rounded* chin that is smooth and free from bumps intimates that its owner is a person who has good business skills and would be a helpful business partner.

However, any *small indents* immediately below the corners of the mouth reveal that this person is slow to delegate responsibility and power, and is therefore likely to clash with employees. But — there is an exception. If such a person has a *square* chin, then he or she can overrule most employee problems.

Both *round and square* chins come to the rescue of those with inferior Career Regions (an area of the forehead described in Chapter 13, The Eight Regions). Although Siang Mien advises those with an indented or flat forehead against employing others or going into business on their own, a good, strong chin can help overcome these problems.

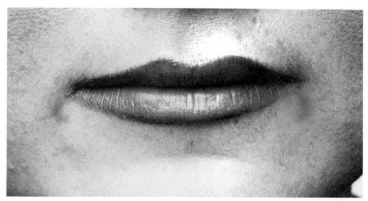

Indents below corners of mouth

A *fleshy, almost three-dimensional, circular* area in the center of the chin reveals that a person's love life is not very smooth. This same circular area also indicates a powerful sex urge. Siang Mien shows that the more three-dimensional the circle, the more sexually demanding its owner.

Fleshy, almost three-dimensional circular area on chin

Cleft chin with dimple

A surprisingly large number of people have a *cleft* or *indentation* in the chin. Some have a cleft with a dimple. The main significance of any one of these features is that its owner enjoys praise, some even craving the spotlight. Many people with this chin marry more than once.

Beards and Mustaches

Not many Chinese can grow a proper beard, having to be satisfied with thin wisps of hair. It is quite usual for Siang Mien masters to tell their students an old Chinese adage:

> It is hard to touch the reflection of flowers
> in a mirror or the moon in a stream;
> But it is even harder to have all these three —
> good sons, old age, and a long beard.

The early masters of Siang Mien deplored the efforts of men to grow beards and mustaches, believing that a truly civilized man should be hairless and smooth-skinned.

In recent times, the masters have perceived that men grow beards for one or more of the following reasons: to hide an inferior chin or ugly jaw; to conceal a double chin, which, they say, is a sign of overeating and lassitude, and generally goes with a fat belly; to affect intellectual inclinations or assume primitive appearances (Westerners might prefer to call these "artistic" appearances); to conceal pimples, blemishes, and warts; as a result of laziness; to keep warm. This last explanation for growing a beard has gained support since the Chinese themselves climbed Mount Everest.

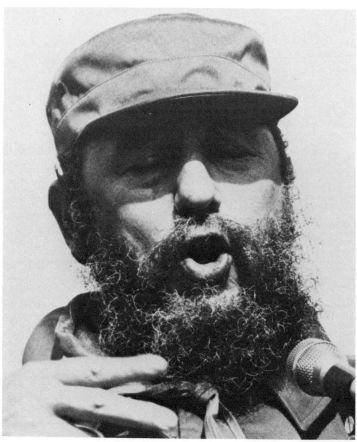

Fidel Castro — Thick beard

Siang Mien reveals that men who grow *thick* beards or mustaches work hard to achieve their ambitions and goals. Able to turn their minds to a number of subjects, many have problems deciding in which field their true talents lie. As a result of searching — mentally and emotionally as often as physically — for an answer, they dissipate their energies, sometimes wasting talent, too.

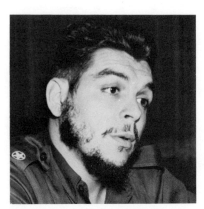

Ché Guevara — Sparse beard with bald patches

Men who can grow only *sparse* beards or mustaches do not know their true worth. Unwilling to push their talents to the limit — often because they fear failure — many could achieve more in life by taking some chances instead of exercising caution.

A *bald patch* (or patches) in the beard tells the world that this man might well have been suited to living in a bygone age, one that would have appealed more to his values and aspirations.

12

Moles

There are countless places on the face where moles can be found, but Siang Mien reveals that those described below are the most significant.

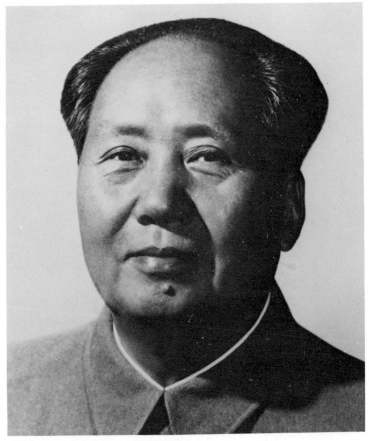

Mao Tse-tung's famous mole

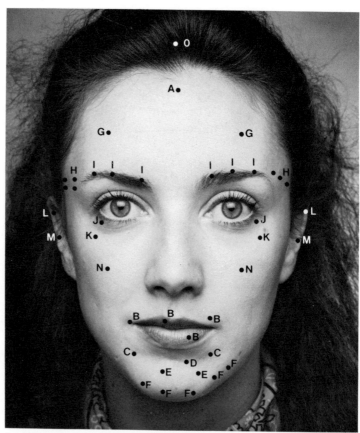

A. Mentally matures early

B. A mole anywhere on the lips or close to the corners of the top lip reveals a general enjoyment of food, but digestive problems are likely after age forty.

C. Quick to make decisions

D. Serious thinker at an early age

E. Rather aggressive and stern, but able to supervise others

F. A mole on the chin (except mid-chin) or moles scattered around the chin signify a lonely old age.

G. Would be a good wife or husband

H. A mole (or moles) between the end of the eyebrows and the hairline denotes a rather pensive person, even melancholic at times, who may not be happy despite a good career or what others might enviously call a "successful life-style."

I. A mole (or moles) on any part of the eyebrow belongs to those who are comparatively well-off.

J. Moles here have different meanings for men and women:
1. a woman: If the mole is on the left, she outlives her husband. If the mole is on the right, her children have some health problems.
2. a man: If the mole is on the right, he outlives his wife. If the mole is on the left, his children have some health problems.

K. This is the "beauty-spot" position near the cheekbone. Two moles (one on each beauty-spot position) increase a person's power, but a single mole reduces personal power.

L. This person is more gifted than average.

M. There are obstacles to accomplishing important tasks. If the middle of the outer circle (edge) of the ear is pointed, this person is very ambitious.

N. This mole is right in the middle of the cheek. Those with a mole on *one* cheek will die in a place far from where they were born. A mole on *each* cheek signifies a happy old age (except for those whose chins are poor; see Chapter 11, The Chin).

O. This is the luckiest mole of all. In fact, it is the luckiest part of the head, but unless you are bald on top, finding out whether you have this spot will be tricky. This mole means that its owner can change bad to good.

These are the fifteen most significant moles. The masters of Siang Mien know that there are also a number of moles not located on the face that reveal important information about people. However, because of the intimate parts of the body involved, you may not have occasion to discover whether many people have these moles or not.

- On the kneecap = can keep money
- In the middle of the groin = oversexed
- Very center of the armpit = money-maker
- Immediately below the navel, half an inch to either side = kind; has original ideas
- Between the buttocks = artistic; eager to learn

The Eight Regions

In addition to the Three Zones (Chapter 4) Siang Mien divides the face into Eight Regions, eight being considered a lucky number by Siang Mien practitioners:

1. Life Region
2. Pulse Points
3. Career Region
4. Wealth Region

5. Friendship Region
6. Parental Region
7. Health and Energy Region
8. Love Region

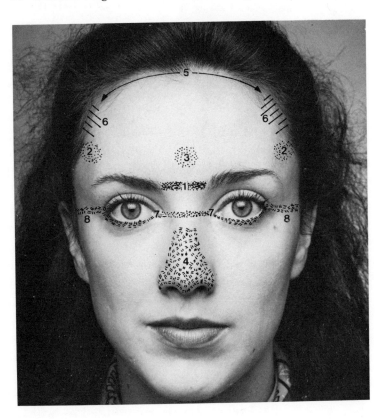

1. Life Region

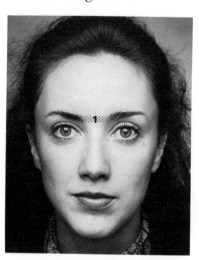

This is the area between the eyebrows. As the most important region of the face, it governs everything about us. If it turns gray suddenly, life is in danger.

Most Chinese can talk about life and death without fear; they do not suffer the inhibitions that make many people regard death as a taboo subject. "The world's affairs are but a dream in spring," they say. "Look upon death as a going home."

The masters of Siang Mien believe that a good life is one that is stable, advancing smoothly without too many highs and lows in health, luck, or any aspect of personal behavior. This does not mean that life has to be dull. Confucius called this steady path of good fortune the Golden Medium, and urged all to seek it.

Those whose Life Region is *wide, smooth, and flat* are most likely to attain the Golden Medium. The region should be one and a half to two fingers wide, more if the face is wide. The wider the Life Region, the more tolerant, forgiving, and generous a person is. Smoothness and flatness of the Life Region also contribute to wealth.

Conversely, someone with a *narrow, bumpy* Life Region tends to bear grudges and is rarely noted for generosity.

The adverse effects of a *poor forehead* — bumpy, flat, very narrow, or pointed — will be mitigated for

those who have a good Life Region that is smooth, flat, and wide.

A Life Region that is *narrow and slopes abruptly toward the nose* indicates an uneven ride with lots of ups and downs, and little likelihood of accumulating a great fortune.

A Life Region that *slopes abruptly down toward the nose, coupled with a prominent area immediately above the eyebrows,* spotlights a twenty-fifth birthday that heralds a period of hard work that could be a turning point, with every chance of a much smoother life to follow.

Life region sloping abruptly toward nose and prominent area immediately above eyebrows

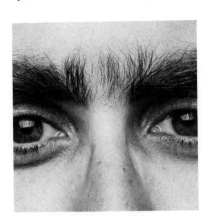

Hair growing in this region (sometimes as an extension of the eyebrows, but not necessarily) is a trait of ungenerous and unforgiving types, so it is best not to tread on the toes of those who have this feature. (See also Joined Eyebrows, page 77–80.)

Hair growing between eyebrows

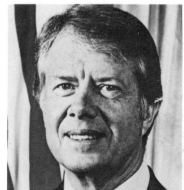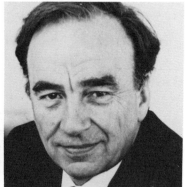

Jimmy Carter and Rupert Murdoch — Worry crease

The worry crease is a line, or series of lines or grooves, that runs down the Life Region between the eyebrows and symbolizes one or more of the following: a person who works hard; who does not get much parental assistance or encouragement in his or her career; who left home early; or left home to travel abroad.

2. Pulse Points

The two Pulse Points can be located by pressing two fingers around and against the temples until the places where the pulse beats most strongly are found.

The Pulse Points tell whether people have easy lives or not.

Good Pulse Points are *full, rounded, and hairless.* Less desirable ones *slope away, or are hairy, or both.* People with hair growing at these points have to work relatively hard throughout their lives, expending a lot

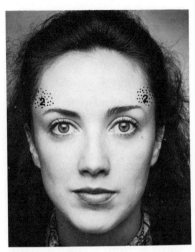

Pulse points

of energy, some of it unnecessarily. This obdurate determination to drive oneself to achieve a goal is described by the Chinese with the saying: "If you continually grind a bar of iron, you can make a needle of it."

Siang Mien shows that it is advisable when studying people's foreheads to consider the Pulse Points with care. Some people may have one or more of these qualities that constitute a good forehead — wide, deep, rounded, smooth — yet have poor Pulse Points. Such people may appear to be happy, but flawed Pulse Points signal many unsolved problems, some of which arose in childhood. The Chinese describe such people as "those who laugh on the outside and cry on the inside."

On a *narrow forehead*, the Pulse Points and the Parental Region (the sixth region described in this chapter) are close together. Siang Mien associates this formation with emotional ups and downs that lead, in some cases, to periods of emotional imbalance.

3. Career Region

This is a vital area, and third in importance of the Eight Regions.

Situated centrally, above the Life Region and immediately above the eyebrows, the Career Region was used by the original masters of Siang Mien to estimate how far a man would advance up the imperial ladder of power. Readings of this region even enabled the masters to predict whether a person would rise to a top position at the emperor's court. Now, students of Siang Mien look to this area as a guide to careers in general.

A good Career Region has a *smooth and rounded bone structure.* Not only is this indicative of a successful career, but it shows that someone so endowed can count on the support of bosses and subordinates, as well as outsiders.

Over the centuries, the Siang Mien masters have noticed that those whose Career Region is good can afford to make mistakes in business, for they are able to recoup losses.

An *especially indented or flat* Career Region is a sign that one should not go into business on one's own or be an employer, for the chances of surviving more than five years are slim. By then it may be too late to find a good job.

Those with *indented, angular, or bumpy* Career Regions are not to be trusted, said the founding fa-

Yehudi Menuhin — Good career region

thers of Siang Mien. While this may be too severe a
judgment today, it can be said that although those
with a poor Career Region are not necessarily more
dishonest than anyone else, many have themselves
learned to be mistrustful of others.

Those whose Career Regions are imperfect are keen

to make the most of every opportunity, and many believe in the Chinese proverb that "learning that does not advance each day will daily decrease." Success, if it comes at all, is unlikely before age thirty.

Siang Mien adds a cautionary note: there is a considerable gap between ambition and achievement for many with poor Career Regions; to be forewarned lessens disappointments.

The Career Region and the Chin There is an important Siang Mien link between the Career Region and the chin that is a further indicator of business skills. A good chin that is *full, smooth, and rounded* can counteract the disadvantages of an indented or flat Career Region, so there is no reason why those with such a chin should not embark on a business venture.

It is also worth considering the shape of the chin when choosing a business partner; a good chin confirms that its owner will be a helpful associate.

A *strong, square chin* is also able to offset the weaknesses associated with an inferior Career Region, but in either case — a square chin or a round one — even the business flair attributed to the chin is weakened if there are small indents just below the mouth tips on each side of the mouth. (See also Chapter 11, The Chin.)

4. Wealth Region

The nose is the only *organ* of the face that is one of the Eight Regions. All the rest are *areas* of the face.

The Wealth Region begins immediately below the

Wealth region

bridge of the nose. The nose reveals whether or not a person can make and retain money, so there is truth in saying that some people have a nose for money.

The masters of Siang Mien have devised a picturesque concept for the nose: if it is *wide across the top* like a money box, plenty of money will fall in. A *big* nose can hold more money, but if the *nostrils show* when a nose is viewed full face, the money falls out of the bottom. *Small* noses, like small money boxes, cannot hold much money.

Harold Robbins —
A good nose for making money

The ideal nose is *straight and without bumps,* and it has a *round, plump tip* that is supported by *fleshy sides.* The *nostrils* should be *concealed* when the face is viewed full on.

This early concept was added to later: if the *lower ridge* of the nose is *bumpy or marred by moles, lines, or blotches,* the money supply is threatened by inefficient paymasters or bad debtors.

Siang Mien adds an afterthought about the *chin,* linking it with the nose in matters of wealth. A round or square, slightly protruding chin permits one to retain, or perhaps add to, a fortune in later years. If the chin recedes, it is advisable to entrust your fortune — however large or modest — to the care of a trustworthy person or institution, and not attempt financial decisions on your own behalf.

Siang Mien shows that money and property — in other words, material wealth — are important components of good fortune. The following ancient proverb therefore appeals to most Chinese: "If you are poor, though you dwell in the busy marketplace, no one will inquire about you. If you are rich, though you live in the heart of the mountains, you will have distant relatives."

The nose is more than the Wealth Region, as you have seen in Chapter 7, which features different types of noses.

5. Friendship Region

"New clothes and old friends are the best," say many who practice Siang Mien. By looking at the Friendship Region, Siang Mien students can tell who is likely to make friends easily.

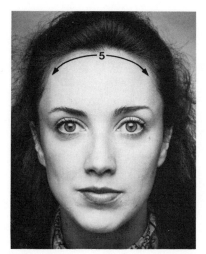

Friendship region

The Friendship Region is located where the top of the face meets the hairline. This is a curious region that also reveals certain aspects about travel.

Siang Mien coinsiders a good hairline one that is *high and sweeps smoothly* from one side of the face to the other. The *two corners*, which should be *wide*, should also be *hairless*.

Princess Margaret — Good friendship region

Robert Taylor — V hairline

Those with good Friendship Regions not only make friends readily, but also find that their friends are able and willing to help them when help is required. These are indeed fortunate people, for they can also count on assistance from their family.

Those, however, who have *hair growing on the corner areas* of the Friendship Region cannot depend

on help from their friends, who, in most instances, not only are less capable but also are poorer.

Based on their observations of foreign visitors to China and on the experiences of Chinese emissaries who journeyed abroad, some Siang Mien masters during the Ming dynasty noted that a characteristic of some who traveled far or frequently was a type of hairline that would today be described as the "widow's peak"; that is, a hairline that dips in the middle of the forehead to form a *V* and rises above each corner to form a rounded or pointed peak.

They went on to add that many of these people form friendships easily, but pay to keep them. Pleasant though these friendships may be, few will last a lifetime.

6. Parental Region

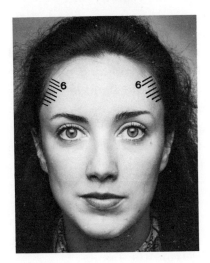

At each end of the Friendship Region, and immediately below, is the Parental Region. Its importance should not be underrated. The masters of Siang Mien and the sage Confucius believed — as indeed do nearly all Chinese today — that children should honor their parents.

The founding fathers of Siang Mien perceived that those whose Parental Region is *nicely rounded and curved* inherit more character traits from their parents than those whose Parental Region *slopes back* from the face.

This is likely to be bad news to those who consider their parents to be particularly awful. But, said the ancient Siang Mien masters, there are unlimited opportunities for self-improvement, and no one should blame parents for bad fortune.

The masters also quoted a number of instructions concerning respect for parents, many of which would upset the twentieth-century man and woman, but one of which is worth considering: "If you wish for dutiful children, first show filial piety to your own parents."

Though countless venerable sages of ancient China spoke about filial piety and inheriting wisdom, the Siang Mien masters were more concerned that parents should be able to assist their children materially.

So, their observations led to the evolution of the theory that those whose *Parental Region is good but whose Pulse Points* (the second region) *and Friendship Region* (the fifth region) *are inferior* would, alas, be in no position to be assisted financially.

Conversely, they remarked that those who have all *three regions nicely smooth and rounded* would be well-off because their parents would be able to introduce them to influential people.

While modern students of Siang Mien consider the links between family influence and wealth and the three regions of the forehead less applicable today, they do not deny another connection that the founding fathers of Siang Mien made between these three regions and intelligence; that those fortunate enough to have three nicely smooth and rounded regions have inherited keen intelligence from the family.

Without realizing it, the earliest practitioners of Siang Mien were identifying, through observing faces, the influence of genes, long before the study of genetics became scientific.

As with the Friendship Region, the early Siang Mien masters were preoccupied with *hair covering* the Parental Region. They interpreted a person's hairiness there as a sign that he or she had a parent who had mistresses or lovers, or who remarried.

They linked this same marital and sexual pattern of behavior in one's parents to anyone whose *forehead is higher on one side* than the other, and to those whose Parental, Friendship, and Pulse Points *all slope* markedly away from the face.

7. Health and Energy Region

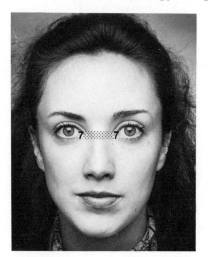

This is the area between the eyes, including the bridge of the nose. It is immediately below the first region — the Life Region.

A *wide, flat* Health and Energy Region is a sign of good health. A *narrow* one reveals health troubles, including a lot of minor problems. In some cases, people with narrow Health and Energy Regions may show a low resistance to disease, so they should take care when traveling in countries where diseases are endemic.

In the fourth century A.D., Chinese

alchemists, some of whom practiced Siang Mien, devised a set of rules that, sixteen hundred years later, still ring true. Simple though the instructions sound, they are also pure common sense, a commodity that even the best of us sometimes find in short supply. Here are some examples:

- Put on extra clothes before feeling cold.
- Eat before feeling hungry.
- Never eat to capacity.
- Eat moderately before going to sleep.

They also had this to say to those who had problems rising early in the morning:

- To get up early for three mornings is equal to one day in time.

Lines across the Health and Energy Region are quite common, but they have a variety of causes and meanings.

Some lines represent past problems, even catastrophes, that occurred in childhood. Others forewarn of

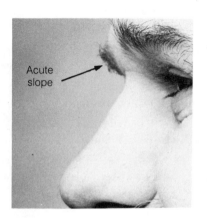

Acute
slope

something unpleasant at around age forty-one, though this may be nothing more serious than a short illness of minor consequence. Or, lines running through this region can be signs that an operation is recommended around the age of forty.

More likely to be of lasting significance than any lines, said the early practitioners of Siang Mien, is an *acute slope* between the Life Region (the first region, situated between the

eyebrows) and the Health and Energy Region. This indicates that minor health problems will occur. They will be more of a nuisance if this area is also *very narrow.*

Wide health and energy region

As may be expected, those whose Health and Energy Region is *wide* have reserves of stamina and energy that enable them to stay up for nights in a row, if necessary. These are, or could be, the party-loving types, or those who do best at examinations by cramming the facts in the night before. If their sex drive is keen they can tire their partners by their energy.

Sometimes the eyebrows extend into this region. *Hair* at this point evinces certain troublesome characteristics: people who have it get depressed easily and are liable to imaginary illnesses and problems. Many take offense easily, too.

Those whose *eyebrows join* in the middle or who have *hair growing* in the Health and Energy Region are likely to be both ungenerous and easily offended.

8. Love Region

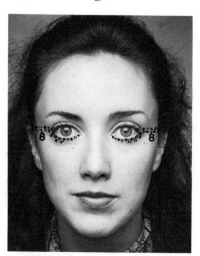

The Love Region is the area under the eyes, continuing horizontally from the ends of the eyes to the hairline. Siang Mien does not link sexuality to the Love Region. The sex drive is revealed by the Mouth (Chapter 8), Chin (Chapter 11), Ears — especially the lobes (Chapter 9), Eyebrows (Chapter 5), Eyes (Chapter 6), and even by Moles (Chapter 12).

Most of the earliest masters of Siang Mien saw no connection between love and marriage, either. It was a time when marriages were arranged by parents, and love was not a consideration.

"Parents know best" was the accepted attitude, and if love developed after marriage, so much the better. Though arranged marriages are banned in China today, many parents still put pressure on their children to marry a particular person; this is most common in rural areas, where four-fifths of the population of one billion live. But even in these regions there is now more talk of love, brought about in part by the influx of tourists.

The area under the eyes is the region that tells most about love. If it is *pinkish or luminous*, all is well, and the love relationship is going smoothly.

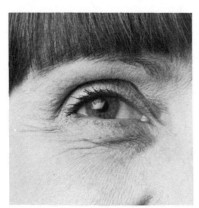

Lines under eyes

It was not until early in this century that Siang Mien masters acknowledged that broken hearts were possible, diagnosing *each line under the eyes* as a lost love. Modern interpreters of Siang Mien attribute these lines not only to heartbreaks, but also to serious disappointments in friendships and family relationships.

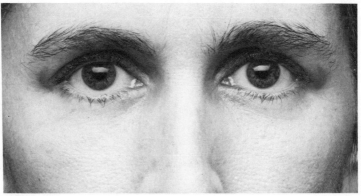

Indentation at corner of eye

An *indentation at the outer ends* of the eyes —that is, a hollow area where the bone is concave — is a characteristic of those who set themselves high standards, and are difficult to satisfy in marriage.

Noticeable *bags under the eyes* are deemed to affect one's fortune adversely. But, a *fleshy* area here is an indication that a person has, or could have, bright and intelligent children, though they are likely to be mischievous.

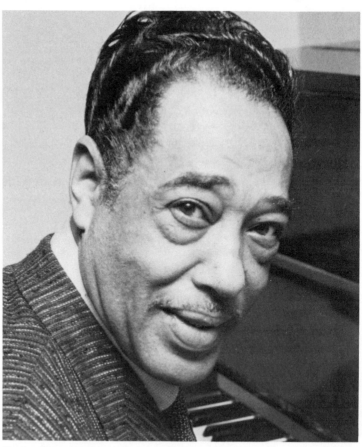

Duke Ellington — Bags under eyes

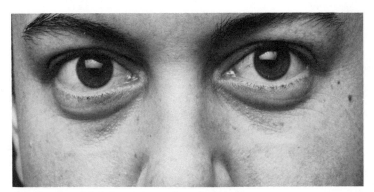

Sunken or bluish area under the eyes

The masters of Siang Mien advise that women who have *sunken* or *bluish* areas under the eyes should take special care of their health during pregnancy.

Wrinkles, including crow's-feet, that appear in the Love Region are normal, according to Siang Mien. Whether we like them or not, wrinkles are a sign of aging, and there is little or nothing that can be done to prevent their development.

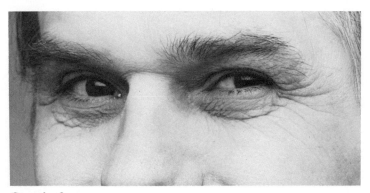

Crow's feet

Reading Some Famous Faces

Princess Diana

Leonard Bernstein

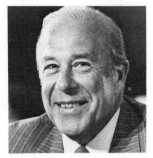

George Shultz

Jacqueline Onassis

Yuri Andropov

PRINCESS DIANA

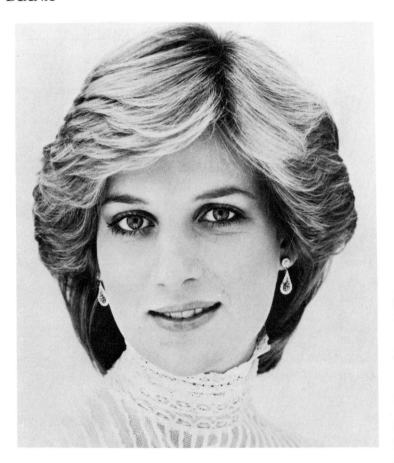

The chances of becoming famous before the age of thirty are increased if the ears stand above the line of the eyebrows. Princess Diana has just such ears, although they are usually concealed beneath her thick hair.

Siang Mien further shows that those with high ears who also have eyes of different sizes will have a sudden upturn of fortune that lifts them above the ordinary run of life; the princess's left eye is indeed smaller than her right one. Siang Mien has another observation: those who have eyes of different sizes often have stepparents.

Her right eye is Dragon shaped, revealing that she is brave and good company. The other eye is a Peacock shape, a feature normally associated with those who can be charming, but who are capable of unnerving jealousy if the object of their love or desire slips from their grasp.

As if to confirm these Siang Mien observations, the princess has thin eyelashes, which tell us that, although she is normally placid and cool, she also has a sharp temper.

The line that runs from the inner eye across her left cheek is still faint because she is young. Yet it warns against the possibility of being used by others trying to attain power or influence. It also warns of periods of disharmony at home after she has reached thirty.

Until she slimmed down after her marriage, the princess's cheeks were fleshy and well padded and they would have acted as a buffer against anyone trying to take advantage of her. But the Siang Mien reading changes as the face changes, so it has to be said that now she, like anyone else with sunken rather than plump cheeks, is less able to parry the unwelcome plans others may have to make use of her.

Hers is a Jade face, an auspicious shape that contributes to its owner's willpower and strength of

character. This shape belongs to many whose early life has been marred by unhappy events. It is during such times that the determination to overcome setbacks takes shape. Though it is not always apparent, Jade people are tough.

Because the measurement of the top part of her face (from hairline to the top of the eyebrows) is shorter than the lower part of her face (from nose tip to chin), Princess Diana is more a do-er than a thinker, more practical than intellectual. The good curve of her eyebrows shows that she has a good deal of common sense, though the presence of hairs in her left eyebrow that grow downward (instead of upward or sideways) reveals that the princess is immature and sometimes finds herself at odds with her family, friends, and even life itself.

Her well-concealed nostrils and a rather tight notch just above the earlobes together show that she values money and will not give to anyone she considers does not merit her generosity.

This young woman will one day be a queen. Her excellent teeth reveal her ability to adapt quickly to new responsibilities, and the generous space between her eyes shows that she has inner reserves of energy and stamina her future role will require.

LEONARD BERNSTEIN

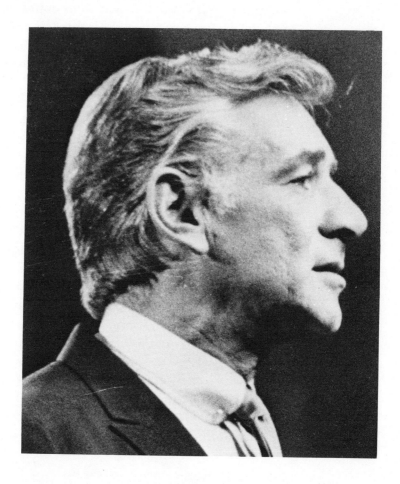

This is the face of an enigmatic man, for it is a combination of two Siang Mien face shapes — King and Fire. Together they identify a person with a fiery personality, tempered by private moments of deep reflection.

The mixture of Fire and King, plus thick eyebrows and hair encroaching on the sides of his forehead and cheeks, tells the world that here, indeed, is a versatile and multitalented person who defies all efforts to type, classify, and pigeonhole him. That his cheeks are the widest part of the face shows not only that he arouses envy in others, but also that he will not tolerate sham or hypocrisy.

Those with elements of the Fire and King face are alert, quick to learn, bright, sensitive, nervy, and tense. They work hard and make friends readily. They are better at leading than being led, and want everyone to agree with them. The most successful ones tend to be overconfident, but Siang Mien warns against taking things for granted with this advice: "If you have happiness, don't use it all up. Don't rely on your present good fortune; prepare for the year it may leave you."

His forehead slopes sharply away at the sides, revealing that childhood hopes and dreams were often misunderstood by elders. There is another pronounced slope from the Life Region (the area between the eyebrows) toward the bridge of the nose; this, together with a well-developed bone structure under the eyebrows, tells the Siang Mien observer that this man had an opportunity at around twenty-five that, if seized, could have been a turning point in his life.

There is further evidence that he is an enigmatic man: the King element in the face shape informs us that he is militant, tough, persistent, and very persuasive, yet the generous length of his forehead in relation to his chin shows that he has gloomy periods of introspection.

His eyes slope down, a further sign of a reflective

temperament, perhaps even of pessimism. But there is an extrovert, dramatic side of this man best seen from the mouth with its thicker lower lip. Such a lip enables its owner to communicate easily with people, an asset for anyone who chooses a career in which public speaking and contact with the masses are requisites. Many artists and actors have such a mouth.

His eyes have a penetrating, persuasive gaze, and their hint of a triangular shape means that he can mold and influence the opinions and feelings of others. Though his eyebrows are thick, the roots are largely visible, especially those of the right eyebrow, indicating that even those people who might feel themselves, rightly or wrongly, to be the "victims" of his aggression or persuasion respect him.

This is a fine money-making nose: large, wide, with a fleshy tip and nostrils that are concealed when the face is viewed full on. This nose, together with earlobes that protrude slightly and point toward the mouth, plus a strong and protruding chin all indicate — barring accidents — a comfortable old age.

His ear has a prominent inner circle, a sign of efficiency, thoroughness, powers of concentration, and a high work output. The notch, immediately above the earlobe, is quite wide, which is indicative of a person who is generous to those he likes, loves, or respects.

The nose bridge is wide, signaling vitality, energy, and enthusiasm that can tire others emotionally and physically. The nose is long, suggesting that he is willful and stubborn. His eyebrows are set close to the eyes, revealing that he is an impatient man who feels that life is for living and that there is no time to rest on one's laurels.

GEORGE SHULTZ

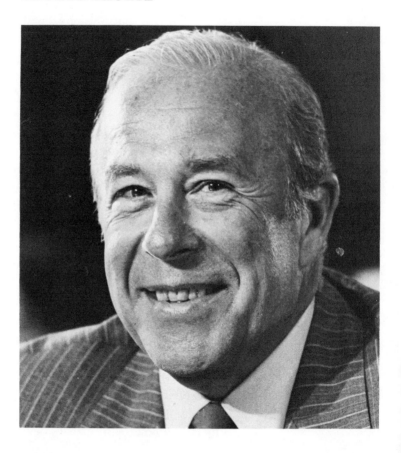

Siang Mien identifies this as a Bucket-shaped face, which is associated with someone who is well adjusted and able to draw on inner reserves of strength in crises. Very rarely do such people lose their balance, yet this air of stability and self-assurance can sometimes unnerve those closest to them, making loved ones feel superfluous.

This face shape belongs to someone who is kind, patriotic, and aware of his own importance, but few know whether he acts from the heart, or in order to be praised. Very small indents at the mouth corners provide a clue: there are times when he doubts that what he is doing will have any lasting influence.

The smoothly rounded, wide, deep forehead reveals cleverness and an ability to think clearly and logically. The center of the forehead shows he has a good memory, but the lower part — which is bumpy — indicates lack of intuition and imagination, and boredom with gossip or rumor, for which there is a Siang Mien saying: "He will not recount in a side street what he has just heard in the main street."

That he is quick to learn is confirmed by his well-shaped forehead coupled with a nicely rounded skull. However, he is not a totally brilliant thinker, for this requires more evenly arranged teeth, plus better-shaped eyebrows.

His eyebrows are irregular, one being more triangular than the other. This indicates that he can be selfish, but capable of courage when the going is tough. Whenever he lacks ideas of his own, he is able to improve on the suggestions of others after carefully examining his options. These eyebrows are scant in places, a sign of health problems, so the wisest of those with this type of eyebrow engage in sport and exercise to compensate for unhealthy sedentary occupations.

A nose as high as this belongs to someone for whom money is less of a problem than it is for most. However, with his fairly long nose and rather large nostrils, he should heed the Siang Mien warning that old age will be lonely unless he adopts a freer spending

attitude toward others. Furthermore, anyone whose notch, that is, the small niche situated immediately above the earlobe, cannot comfortably accommodate the width of a forefinger has a careful attitude toward spending money. His notch is narrow.

The good gaze of his eyes inspires confidence, and friends can count on his loyalty. The fleshy area under each eye together with the shape of his *Jen-chung* (the groove situated between the base of the nose and the middle of the upper lip) reveal that he is capable of inspiring a sound family tradition.

The squarish ears indicate wealth and cleverness. The inner circle of the ear is not well shaped, being lower and more recessed than the outer circle. This suggests that executive work and intensive decision-making do not completely appeal to him, but that he is able to adapt to most roles because his intellect, knowledge, and mental skills — as revealed by his admirably shaped forehead — permit this.

The mouth is rather small, showing that he is disinclined to turn to others for help or advice, often preferring to keep problems to himself. This mouth also reveals that its owner can be inventive and attractive as a lover.

His ears are placed low on the face in relation to his nose, so he can expect to achieve most late in life. Many elderly politicians and world leaders have low-placed ears. The fairly strong chin confirms that after fifty he can expect his career to improve.

Moles in his eyebrows show that he is comparatively well-off, but the series of moles near his upper lip warn that, though he may enjoy good food, digestive problems will increase.

JACQUELINE ONASSIS

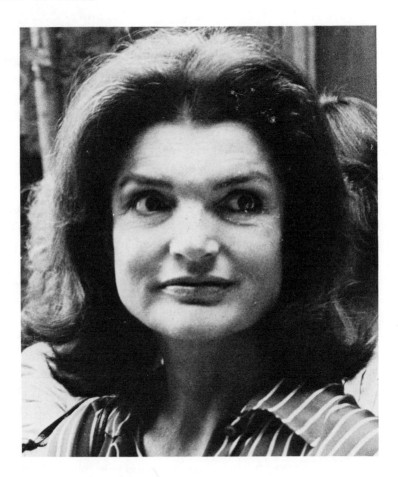

This is not a face generally considered classically beautiful by Western standards, but Siang Mien identifies it as one filled with qualities that bring to its owner periods of outstanding good fortune, com-

bined with restlessness, unsettling bouts of introspection, and the urgent need to withhold from others the true self.

Like Sir Winston Churchill's, hers is an Iron face. Loath to make a mistake, the Iron woman weighs matters before taking action; once her decision is made, she does her utmost to see a project through, often ignoring advice and public opinion. Many Iron women marry several times. They are able — if they so choose — to make a man feel understood.

Because the central area of her face (from eyebrows to nose tip) is longer than her forehead (from hairline to the top of the eyebrows), she is persistent and capable of overcoming obstacles and adversity. Her wide forehead, relatively smooth hairline, and curve of the forehead in profile together reveal that she is intuitive and has a good mind.

Other special strengths are her eyes and nose. With a powerful gaze she can assess her opposition. With a steadfast look she can give the impression that her entire attention is devoted to others, who are irresistibly flattered by her attention. At times her eyes open so wide as to show "whites" above and below the iris in addition to the normal "whites" on either side: she is sensitive to the needs of others and, above all, to her own. Her gaze also reveals humor.

Her thin eyebrows reveal to practitioners of Siang Mien that here is a person who will withdraw from someone she feels is getting close to understanding her. These eyebrows warn that few can penetrate beyond her wall of privacy.

Hair growing on the Pulse Points and Parental Region of her forehead signifies that a parent had lovers

or remarried, and that, although many envy her life-style, she is not as happy as many would imagine. Siang Mien identifies her as someone who laughs on the outside, but cries on the inside.

Her Tiger-shaped eyes permit her to see ahead, sight her quarry, and persist until she has caught it. This is also an above-average money-making nose: wide at the top with a round and plump tip (this latter feature also shows artistry and creativity). The fact that the nostrils show when the face is viewed full on reveals that she is susceptible to bouts of spending and that she will take risks in life, but knows when to pull back. In fact, the combination of these nostrils, and gums that show when she smiles indicates that their owner is liable to bouts of extravagance and generosity, tempered by periods of meanness.

Her cheekbones are the widest part of the face, revealing that she arouses feelings of jealousy and envy in many people. However, shiny and fairly plump cheeks cushion her against anyone who tries to get the better of her.

The ears, though rarely glimpsed, are long, showing that she instinctively knows when someone is trying to use her; she helps only those who she considers deserve help. Plump earlobes tell of a healthy attitude toward love, but few men — maybe none — feel that she truly commits herself to them.

That old age will be good is confirmed by her amazing chin; such a protruding chin also stands for power. However, unevenly shaped teeth and the fact that the two upper central ones are large warn of a temporary decline in fortune around the age of sixty, unless a tendency to stubbornness is checked.

YURI ANDROPOV

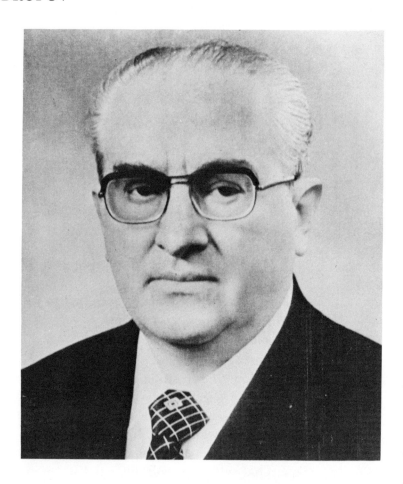

The most fascinating Siang Mien observation about the face of this man is his driving ambition, clearly identifiable because the center of his forehead — which is known as the Memory Band — protrudes.

A mole near the center of his ear not only confirms that he is very ambitious, but also indicates that there are major obstacles that prevent the accomplishment of the tasks he sets his heart on.

His thin nostrils resemble those of Napoleon, and inform the student of Siang Mien that their owners take one or two major risks in their lifetime that lead either to great triumphs or to huge disasters.

This man's forehead is excellent — wide, deep, rounded — indicative of a fine mind: logical, intelligent, astute, intuitive, and with a good memory. Earlier pictures taken before his hair thinned show a slightly uneven hairline and hair growing on the sides of his forehead at the Parental Region. These features indicate an ability to get on well with those whom he considers his intellectual equals, as well as a fear of younger, talented men and women. This latter inadequacy is most likely the result of disharmony in childhood when one of his parents had a young lover.

His are Fox eyes, a sign of native cunning and the ability to disguise his thoughts and intentions from others. Those with Fox eyes are clever at maneuvering and have the patience to wait for an opportunity to snatch the prey they are stalking. The fine eyelashes tell that, though he is cool and controlled most of the time, this is a person who, when roused, can be quite ferocious.

His nose is wide with a plump nose tip and nostrils that are barely visible when the face is viewed full on. The nostrils are supported by fleshy sides, so he could, if he wished, amass a comfortable personal fortune. His fleshy nose tip points to artistic and cultural inclinations.

Although the Health and Energy Region across the bridge of his nose is wide, indicating good health, the appearance in the last two years of two Worry Creases running down between his eyebrows reveals not only that he works hard, but also that he sometimes pushes himself to the limit. Deepening bags under his eyes (touched out in recent official photographs) and red eyes confirm that his health is a major problem.

The right eyebrow is very thick, a hallmark of an autocrat. His protruding ears, which are also much wider at the top, tell the world that he is a self-made man. Possibly because he himself has known harder times, he is slow to offer hope to those who ask favors, preferring not to make promises that he knows he cannot honor. This Siang Mien observation derives from the nearly straight, horizontal line at the point where his lips meet.

Yet, like Colonel Muammar el-Qaddafi, indentations at the corners of the mouth reveal that he feels inferior in the presence of those who he thinks have greater potential for leadership or power.

Such a fleshy chin, combined with plump earlobes and a curvy upper lip, suggests that he is sexually demanding, but his nose tip — though rounded — does point down, revealing to Siang Mien observers that he can be chilly, cold and selfish, as a lover.

Acknowledgments

I am grateful to the following for their assistance in my studies of Siang Mien, and in the preparation of this book:

My Siang Mien master in Shanghai and late master in Guangzhou; Seto Chongchi, National Institute of Metrology, Beijing; Lin Kusen, University of Nanjing, Nanjing, China

Genevieve Young (editor), Pat Dunbar (designer), Jean Crockett (copyeditor), David Arky (illustrator); Juliette Lipeles in New York; Yu Soongkwong in San Francisco

Clare Bristow and Ion Trewin, London; School of Oriental and African Studies, University of London; Society for Anglo-Chinese Understanding, London

Melina Hung, Lai Cheuklau, Amy Wong, Frances Wong in Hong Kong; Professor W. C. Foong and Tham Chanwah in Singapore; the late Yee Gimhing, Melbourne, Australia

Photograph Acknowledgments

The publisher and author wish to thank the following for their kind permission to reproduce photographs: Camera Press, London for the photographs on page 30 (Sven Simon), page 32 (Jon Blau), page 36 (Vivienne), page 38 (CAPA), page 42 (Kurt Wyss), page 44 (John Bryson), page 46 (Camerapix), page 69 *bottom*, page 70 *bottom*, page 80 (Julien Quideau, *L'Express*), page 84 (Leon Herschtritt), page 86 (Tom Hanley), page 92, page 97 (Brian Aris), page 98 (A.S.P.), page 108 (MG/Johnson), page 115 (Max Ehlert), page 126 (Jean Ker, Ilphot), page 128 (David Bailey), page 130, page 134, page 135 (Cecil Beaton), page 138 (Symil Kumar Dutt), page 139 *top* (Interfoto MTI), page 145 (Horst Tappe), page 150 (Ralph Crane), page 151, page 153 (Gerald Buthaud), page 156 (David Bailey), page 158, page 165 (Alan Davidson), page 167 (Michael Evans), page 169 (Snowdon), page 172 (Jerry Watson), page 173 *bottom* (IPPA), page 175, page 179 *left* (BASSANO), page 179 *right*, page 181, page 183 (Ralph Crane), page 188 (Karsh of Ottawa), page 194 (Albert Clack), page 195 (Czechoslovak News Agency), page 197, page 204 *left*, page 204 *right* (*The Times*, London), page 207 (Richard Slade), page 209 (Jerry Watson), page 211 *bottom* (Norman Parkinson), page 224 (Snowdon); Golden Communications for the photograph on page 90; Milton Greene for the photograph on page 96; Jack Mitchell for the photograph on page 142 (© Jack Mitchell); Renate Ponsold for the photograph on page 40; Popperfoto for the photograph on page 74; and United Press International for the photographs on pages 34, 49, 62, 67, 72, 89, 104, 118 (*bottom*), 131, 171, 212, 220, 227, 230, 233, and 236.